T0060212

# Harry Potter™

# FILM VAULT

VOLUME 12

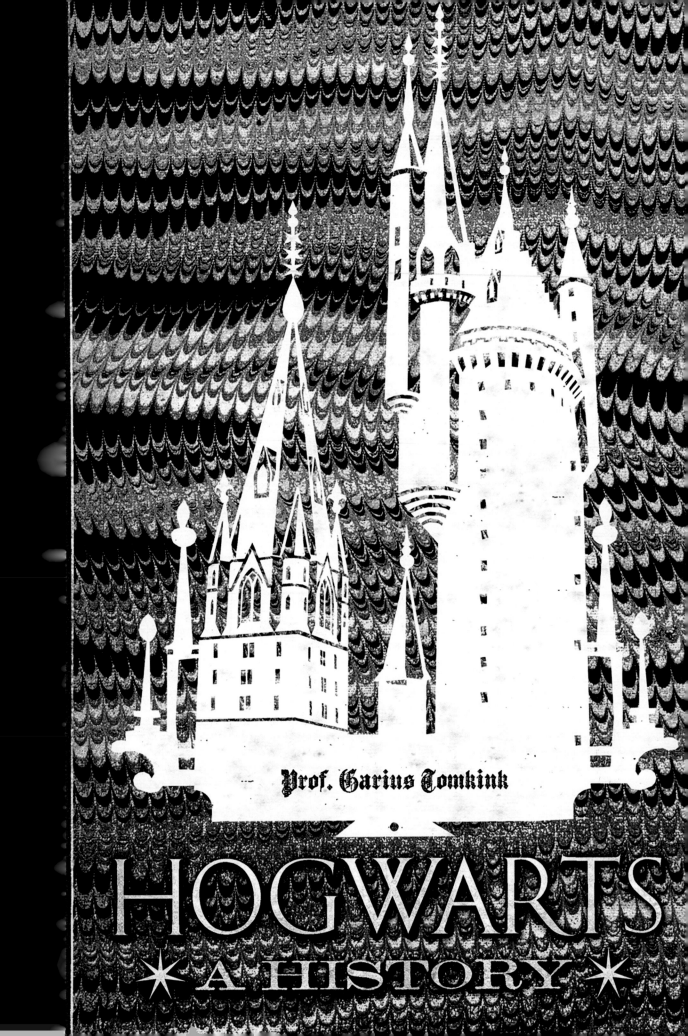

Prof. Garius Tomkink

# HOGWARTS
## ✦ A HISTORY ✦

# Harry Potter™

# FILM VAULT

## Volume 12

Celebrations, Food, and Publications
of the Wizarding World

By Jody Revenson

WIZARDING
WORLD

INSIGHT EDITIONS

San Rafael • Los Angeles • London

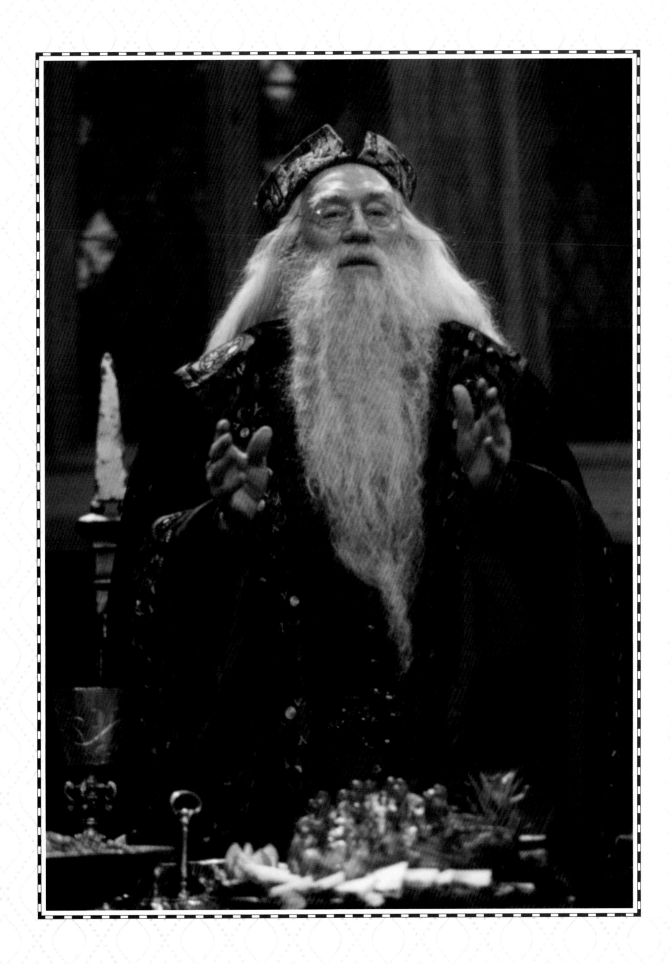

# INTRODUCTION

✴ ☾ ✴

After the Hogwarts Sorting Ceremony for first-year students in *Harry Potter and the Sorcerer's Stone*, where Harry Potter (Daniel Radcliffe) is Sorted into Gryffindor house, the entire school is treated to a feast that includes racks of lamb, bowls of corn on the cob, and myriad roasted fowl. Meals in the Great Hall were elaborate affairs for the hungry students, often featuring luscious-looking desserts and mouth-watering refreshments. In addition to cereals and drinks, meats and sweets, magical menus for Halloween holiday banquets, Yule season celebrations, and the wedding of Fleur Delacour (Clémence Poésy) and Bill Weasley (Domhnall Gleeson) in *Harry Potter and the Deathly Hallows – Part 1* were provided by Stephenie McMillan's set decoration department and Pierre Bohanna's props department. Outside the walls of Hogwarts, wizarding pubs and homes served food and drink; labels for homemade jams, crisps, and Butterbeer were created by the graphics department overseen by Miraphora Mina and Eduardo Lima.

The foods seen on-screen are sometimes real and sometimes not. "Over the course of the films, there [were] some incredible scenes," says Alfred Enoch, who plays Gryffindor Dean Thomas, "but something that always struck me was the food. We'd walk into the Great Hall every year to see incredible meals and desserts and then were told we couldn't eat any! When we'd ask why, they'd tell us it's not real. And that got me every time," he adds with a laugh. "They did such a good job, it's inspiring."

Feasting and publishing might seem to be disparate subjects, but there was certainly food for thought in the newspapers and magazines of the wizarding world. *The Daily Prophet* newspaper was an important part of the story, illustrating the takeover of the wizarding society by Voldemort. Much thought was given to artistically representing how the darkness manifested itself: Early issues of *The Daily Prophet* contained imaginative text layouts and gold lettering in a variety of fonts. As the danger increased, the newspaper's look became ominous, with paragraphs set in regimented rows of black block letters. Fortunately, *The Quibbler*, an alternative publication, provided literally colorful commentary and support for Harry Potter

on the twenty-five thousand pages of it printed for the films.

Textbooks for Hogwarts students were of prime importance, and Mina and Lima showcased bookmaking skills from across the ages in the covers and spines they created. Paper textures and color palettes were determined that would indicate quickly on camera whether a book was expensive or cheap, old or new. Multiple copies of each book were required, and some needed to be made to serve different uses. The *Monster Book of Monsters*, which harasses Harry when he tries to open it in *Harry Potter and the Prisoner of Azkaban*, had two mechanical versions—one that was maneuvered around by a blue-screen pole (removed in postproduction), and another that could fire out shreds of paper from its open pages.

Producer David Heyman stresses that while the goal of creating the world of the Harry Potter films was for them to be fantastical and magical, "we wanted to root everything in a reality," he explains. "We wanted viewers to have a reference through which they could look at and feel, oh, this is familiar, but it's tweaked just a tiny bit." Heyman credits achieving this goal to the collaborative nature of the different creative departments. "Everybody was really ambitious for their craft and wanted to make the very best work they could. We always tried to make each film better than the last.

"[Harry Potter] is not just a British phenomenon or an American phenomenon," he continues, "it's something that touches people from all cultures and all parts of the world. We were given the opportunity to make these films because J. K. Rowling wrote the books and Warner Bros. supported us through all the years. But Warner wouldn't be so generous in their support were it not for the enthusiasm of the fans and their interest and desire to keep coming to these films to have a new and different Potter experience each time. The fans are everything. We wouldn't be here without them."

PAGE 2: The cover of *Hogwarts, A History,* designed by Miraphora Mina and Eduardo Lima. The book was packed in Hermione's enchanted bag in *Harry Potter and the Deathly Hallows – Part 1;* OPPOSITE: Professor Albus Dumbledore, played by Richard Harris, at the closing feast of *Harry Potter and the Sorcerer's Stone.*

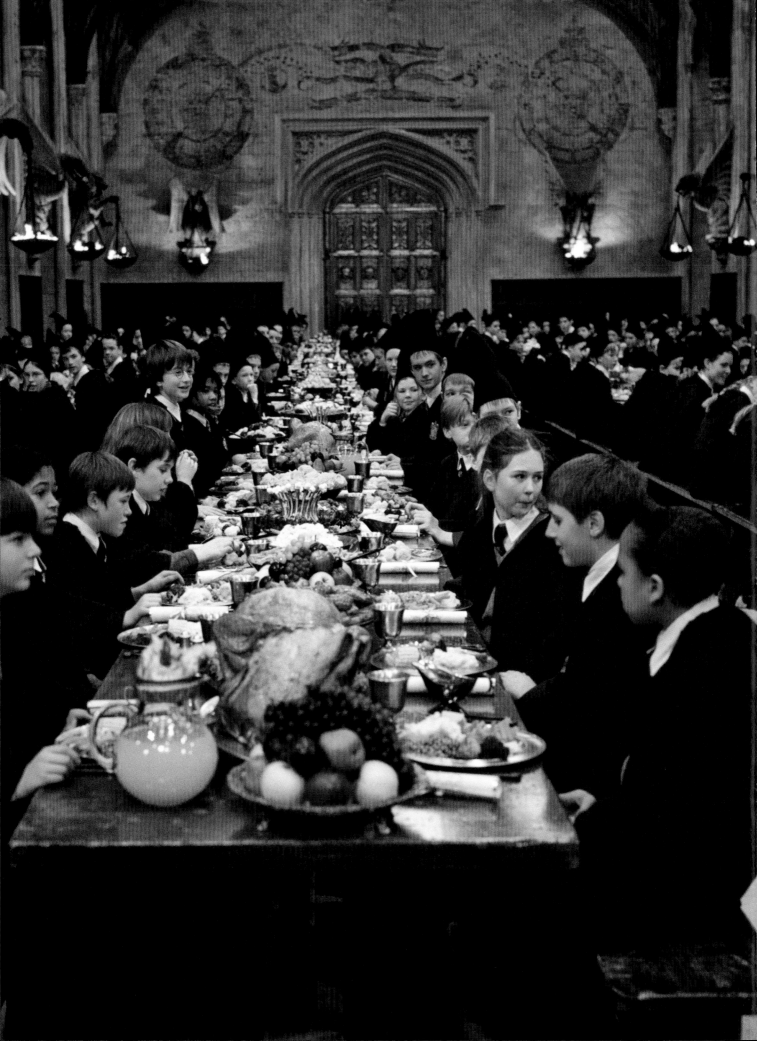

CHAPTER 1

# FOOD AND DRINK

"Two pumpkin pasties, please."
—Cho Chang, *Harry Potter and the Goblet of Fire*

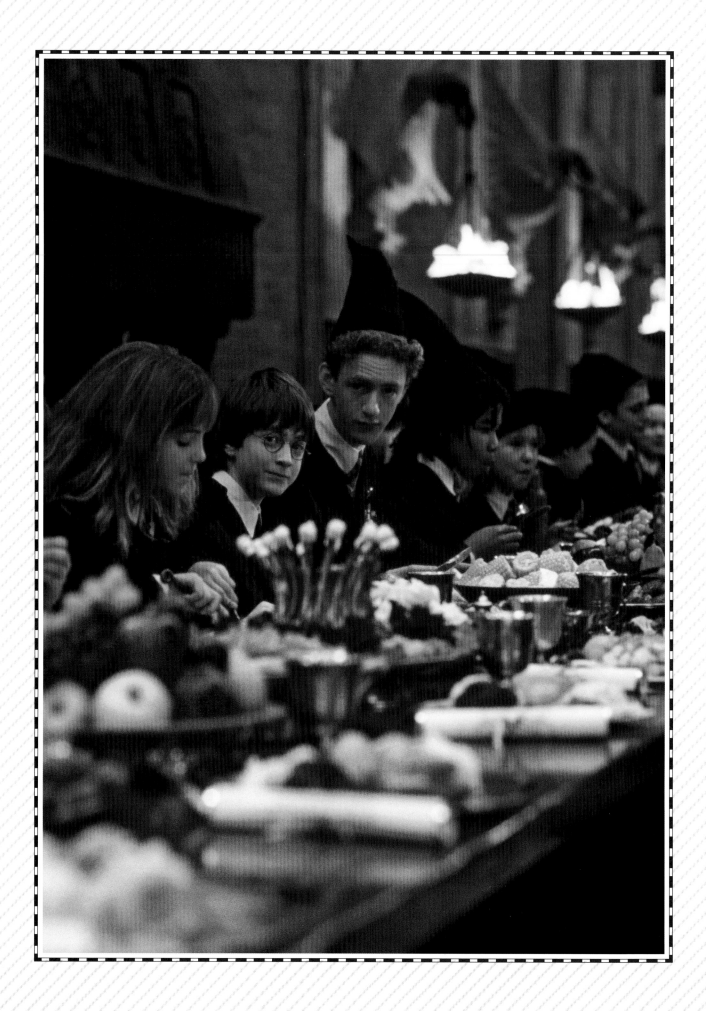

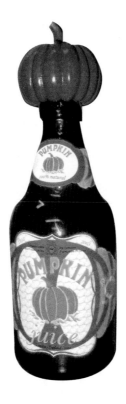

# GREAT HALL FEASTS

*"Let the feast begin!"*

—Albus Dumbledore, ***Harry Potter and the Sorcerer's Stone***

The feasts and sweets served in the Great Hall at mealtimes throughout the Harry Potter films were "catered" by the props department. "I remember that for the very first film, they had to make a choice," says prop maker Pierre Bohanna. "I think they had a five- or six-day shoot of the first Great Hall feast, which would include full turkeys, chicken drumsticks, ears of corn, mashed potatoes, etc." The choice was whether it was more cost-effective to use real food or create replicas, but director Chris Columbus wanted to use real food. "No dummy stuff for him," adds Barry Wilkinson, property master for the film series. "So first we had to figure how we were going to feed four hundred and fifty kids. And you've got to change the food continually because you can't afford to let it go bad under the lights." Four mobile kitchens were placed around the set to accommodate this. Bohanna continues: "And after three days, it was horrible. No one was actually eating it, so the food sat there all day long. It was hard work to keep it warm and inviting, and the smell became prohibitive." Set decorator Stephenie McMillan concurs: "It became legendary how terrible it was."

This approach continued on the second film, although, "there wasn't a scene like that again with main course foods," explains Bohanna. "What tended to happen from then on was that whenever a feast was shown, it was usually the end of the meal, so we did a lot more puddings and things like that." The changes that came to the film series with the arrival of director Alfonso Cuarón on *Harry Potter and the Prisoner of Azkaban* included a switch to molded food replicas. Occasionally, actual food was still used; the profiterole cakes in *Harry Potter and the Order of the Phoenix* were made with real nuts and puff pastries, but the chocolate sauce that was drizzled on top was a secret recipe of the props department—and entirely inedible.

PAGE 6: Feasting in the Great Hall, *Harry Potter and the Sorcerer's Stone*. Four hundred students were fed on tables one hundred feet long; OPPOSITE: Harry Potter attends his first feast in the Great Hall after being Sorted into Gryffindor house in *Harry Potter and the Sorcerer's Stone* (left to right) Hermione Granger, Harry Potter, Percy Weasley (Chris Rankin), Lee Jordan (Luke Youngblood); INSET AND ABOVE: A bottle of pumpkin juice, label designed by the graphics department.

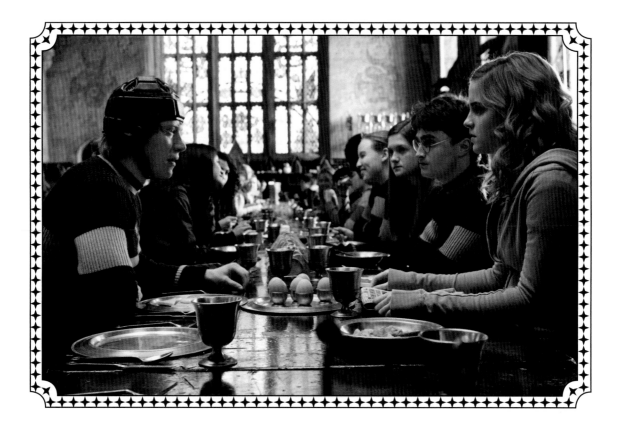

# GREAT HALL BREAKFASTS

*"If the contents are unsatisfactory, please return this product by owl."*

**—Statement on Pixie Puffs cereal box label,**
*Harry Potter and the Prisoner of Azkaban*

Even in the wizarding world, the most important meal of the day is breakfast. Served, as all meals are, in the Great Hall, racks of toast and round disks of butter are bracketed by large jugs of milk and juice that are poured out of a hog's head spout. Fruit preserve jars contain Crazyberry Jam, Forbidden Forest Blossom Honey, and Marmalade with Orange Bits, made by the Hogwarts house-elves, with best-before dates (June in Pisces) on the label. Not surprisingly, cereal is also part of the mix, with the choice of Cheeri Owls and Pixie Puffs as a glimpse into wizarding branding. The graphic designers offered boxes that included prizes, marketing slogans, and ingredient lists. Goodness knows how the students kept their teeth after eating Pixie Puffs (made by Honeydukes), which contains sugar, glucose fructose syrup, African honey, glucose syrup, molasses, magical niacin, iron, fiber, riboflavin, choco, and pixie dust.

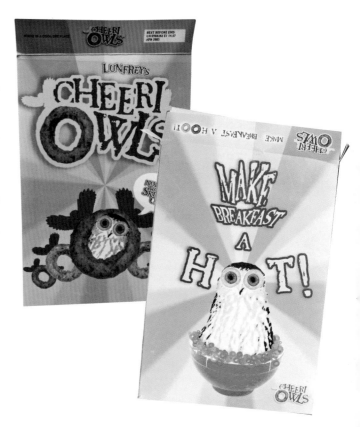

ABOVE: Ron Weasley doesn't have much of an appetite for breakfast before his first Quidditch match as Gryffindor Keeper in *Harry Potter and the Half-Blood Prince*. Showing support across the table are Ginny Weasley (Bonnie Wright), Harry Potter, and Hermione Granger; RIGHT: Front and back views of the Cheeri Owls wizarding cereal box; INSET: A hog's head–stoppered pitcher of orange juice; OPPOSITE: The Great Hall tables, set for a hearty and somewhat healthy breakfast in *Half-Blood Prince*.

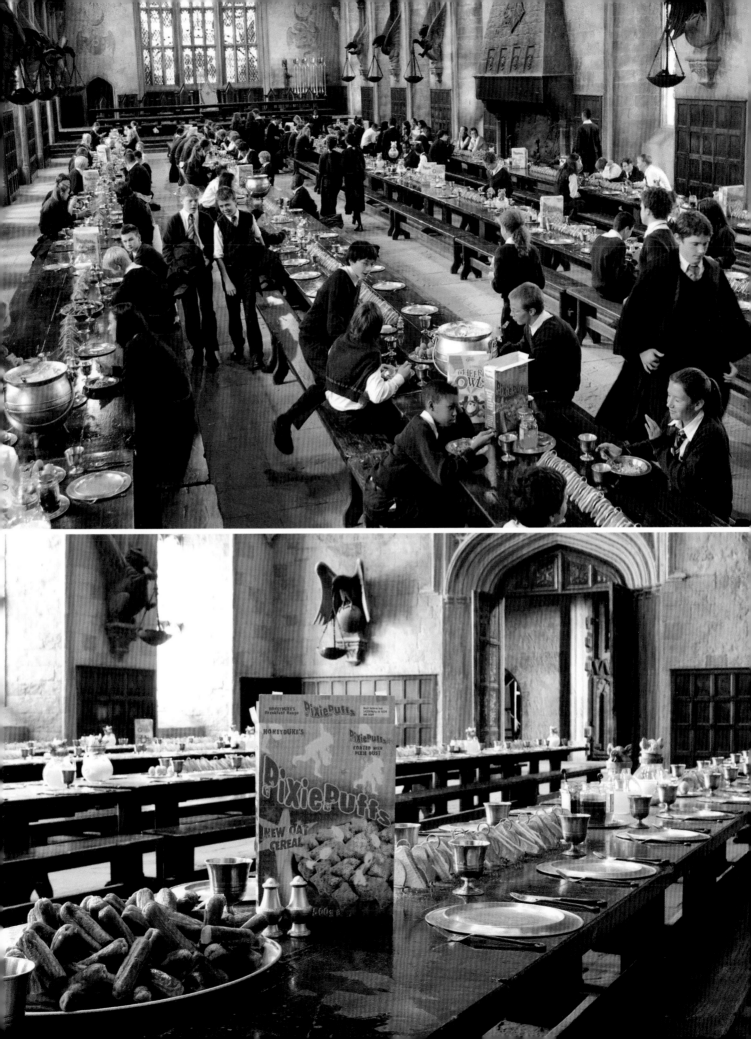

# FOOD AND DRINK ESTABLISHMENTS

*"Leaky Cauldron! Stay away from the pea soup!"*

—Shrunken head on the Knight Bus, *Harry Potter and the Prisoner of Azkaban*

Harry Potter's entrance into the wizarding world in *Harry Potter and the Sorcerer's Stone* is—literally—through the Leaky Cauldron, a pub where wizards can grab a Butterbeer or some pickled eel. It's also an inn, and Harry meets up with the Weasleys during his stay there in *Harry Potter and the Prisoner of Azkaban*. Later in the same film, he visits a tavern in Hogsmeade, the Three Broomsticks, which is also seen in *Harry Potter and the Order of the Phoenix* and *Harry Potter and the Half-Blood Prince*. These places are cozy and communal, and offer opportunities for clandestine talks or safe passages. In *Harry Potter and the Order of the Phoenix*, the nascent members of Dumbledore's Army meet in Hogsmeade at the Hog's Head, a slightly seedier pub that is discovered to be run by Albus Dumbledore's brother, Aberforth, in *Harry Potter and the Deathly Hallows – Part 2*.

Each place serves a selection of drinks, with bottles and barrels labeled by the graphics department, including the ubiquitous Butterbeer. There are several varieties of whiskeys, meads, and other beverages; many of the brands were created by the graphics team. The Three Broomsticks also offers bar food: Black Cat Potato Crisps and the house brand of Spellbinding Nuts.

TOP: The shape of the sign for Diagon Alley's Leaky Cauldron is as distinctive as its name; BELOW: Kegs of Butterbeer, pewter flasks, and a small bell that's rung to indicate last call at the bar; OPPOSITE TOP: The tables are set for patrons of the Three Broomsticks in reference photos for *Harry Potter and the Order of the Phoenix*; OPPOSITE BOTTOM: Labels for some of the Three Broomsticks' offerings created by the graphics department.

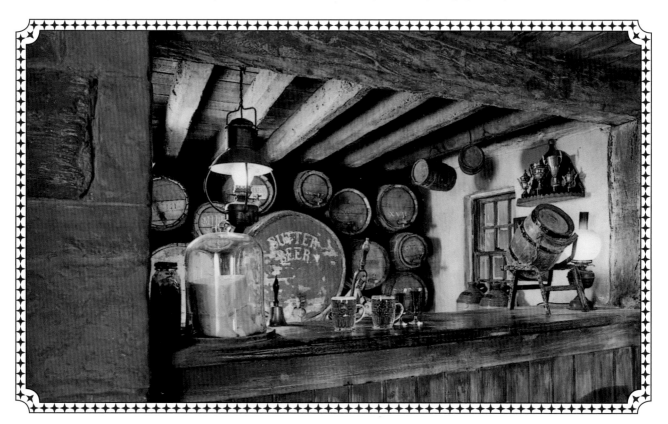

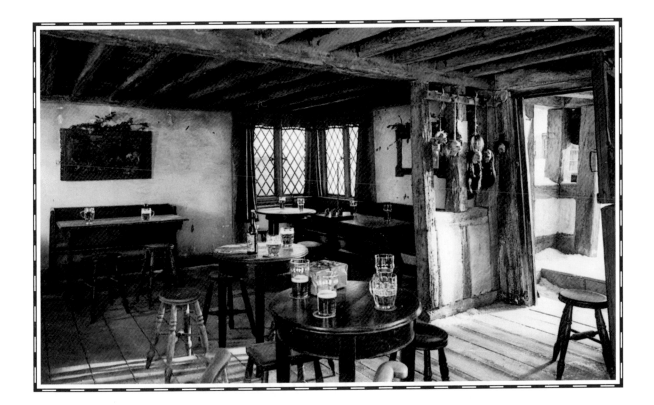

"Oh, the Three Broomsticks and I go way back.
Further than I'd care to admit. In fact,
I remember when it was simply One Broomstick!"
—Horace Slughorn, *Harry Potter and the Half-Blood Prince*

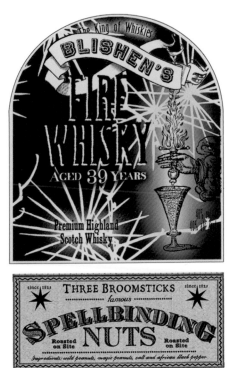

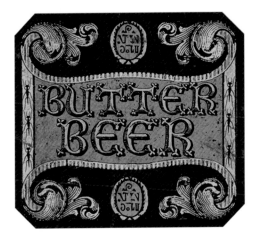

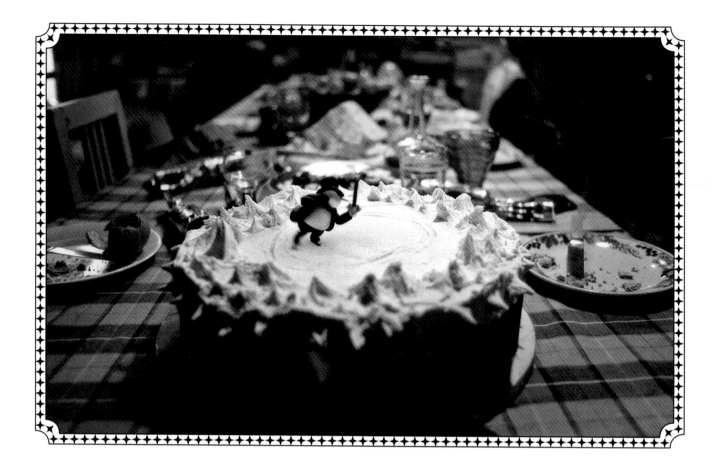

# FOOD AND DRINK AT THE BURROW

Not just crafty at knitting jumpers and scarves, Molly Weasley also makes homemade preserves, lovingly hand-labeled. Flavors include Magnificent Marmalade, Strawberry Jam, and Home Made Yummy Honey.

TOP: A film still of the Christmas Day spread at The Burrow from *Harry Potter and the Half-Blood Prince,* prior to the Death Eater attack; RIGHT: Labels for Molly Weasley's homemade jams were given the same artsy-craftsy feel by the graphics department as her ubiquitous knitting; OPPOSITE RIGHT AND BOTTOM LEFT: Miraphora Mina and Eduardo Lima created the menu and labels for choices available at the Luchino Caffe, visited by Harry, Ron, and Hermione in *Harry Potter and the Deathly Hallows – Part 1;* OPPOSITE TOP LEFT AND CENTER LEFT: Reference photos from the Luchino Caffe set.

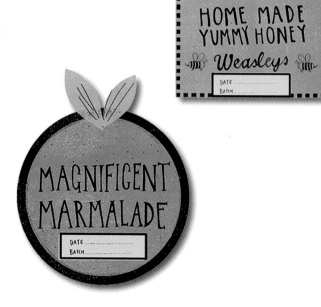

# FOOD AND DRINK IN THE MUGGLE WORLD

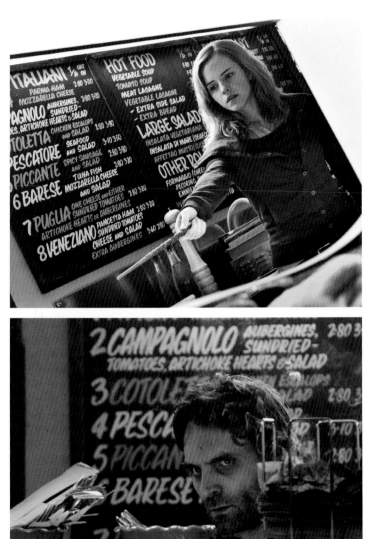

During their escape from Death Eaters who have crashed the wedding of Bill Weasley and Fleur Delacour in *Harry Potter and the Deathly Hallows – Part 1*, Harry Potter, Hermione Granger, and Ron Weasley seek shelter at the Luchino Caffe (named for Miraphora Mina's son). The graphic artists designed drink labels with a decidedly personal flavor, including Lima Lush, a citrus crush fizzy drink.

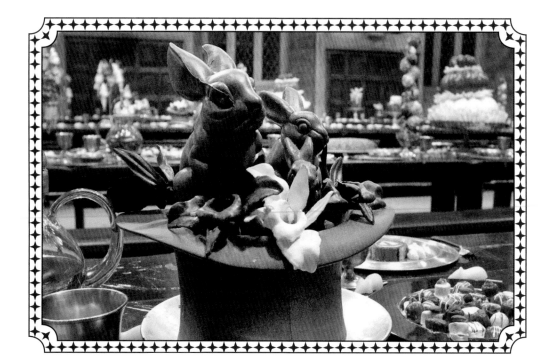

# TRIWIZARD TOURNAMENT WELCOMING FEAST

*"This castle will not only be your home this year,*
*but home to some very special guests as well."*

—Albus Dumbledore, *Harry Potter and the Goblet of Fire*

We had feasts before," says set decorator Stephenie McMillan, "but we hadn't had a feast where we've seen this many desserts and puddings." The Welcome Feast for Beauxbatons Academy of Magic and Durmstrang Institute, the two schools visiting for the Triwizard Tournament in *Harry Potter and the Goblet of Fire*, is a chocoholic's dream. "I wanted this to have a different look than other feasts in the Great Hall, and I knew chocolate would be a good subject for a children's celebration," McMillan says. She also admits to an ulterior motive behind her decision: "I thought this would please the children, because they'd seen boring joints of turkey and roast beef too often. And it's fun to push things to extremes." McMillan designed the scene with three different colors in mind (it is the *Triwizard* Tournament, after all): white chocolate, milk chocolate, and dark chocolate. Many of the creations included all three colors in various ways, but after reviewing the overall tone, director Mike Newell asked McMillan to include some other colors, just to break up all the brown. "We had originally thought to have chocolate milkshakes, but we decided that was going a step too far," McMillan recalls, "so we used a delicate pink tint in the Hogwarts jugs, and put a few pink sweets in as well." Expanding the palette were the gold plates, cups, and cutlery with which McMillan had set the tables since the first film.

The vast array of desserts reflected both traditional and wizardly English treats. They also reflected the talents of the prop, art, and set dressing departments. Production designer Stuart Craig and McMillan first needed to review how the food would appear (not literally) on the tables. "We looked to see what shapes worked well together in giving it quite a lot of height," she says, "because once the children are sitting at the benches, they become something like a dark mass at the bottom of the room." To overcome this, many-tiered cakes, piles of profiteroles, and towers of ice cream paraded down the tables. Another decision that needed to be made was what would be actually baked or boiled and what would be a culinary illusion. "It's practicality that decides it, of course," explains McMillan. "Those things that definitely wouldn't melt could be real, and the things that

TOP: The feast to welcome the Beauxbatons and Durmstrang schools for the Triwizard Tournament in *Harry Potter and the Goblet of Fire* was the first dessert menu the set design and prop makers teams served for the Harry Potter films; OPPOSITE: Set designer Stephenie McMillan's color palette of milk, dark, and white chocolate for the feast was enhanced with a few pink accents and beautifully complemented the gold plates and cutlery used in the Hogwarts Great Hall.

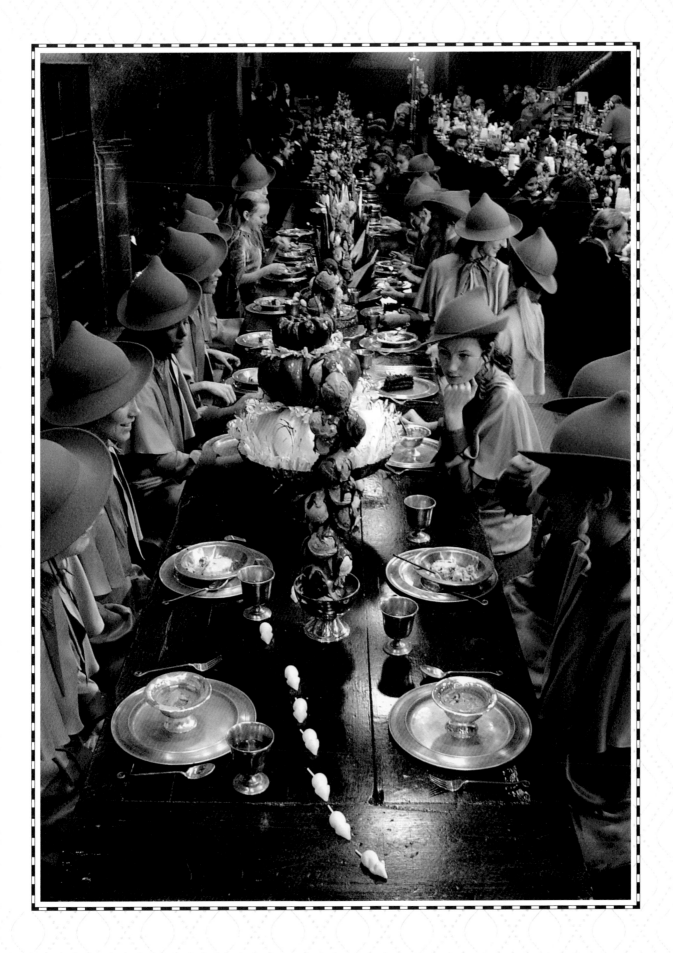

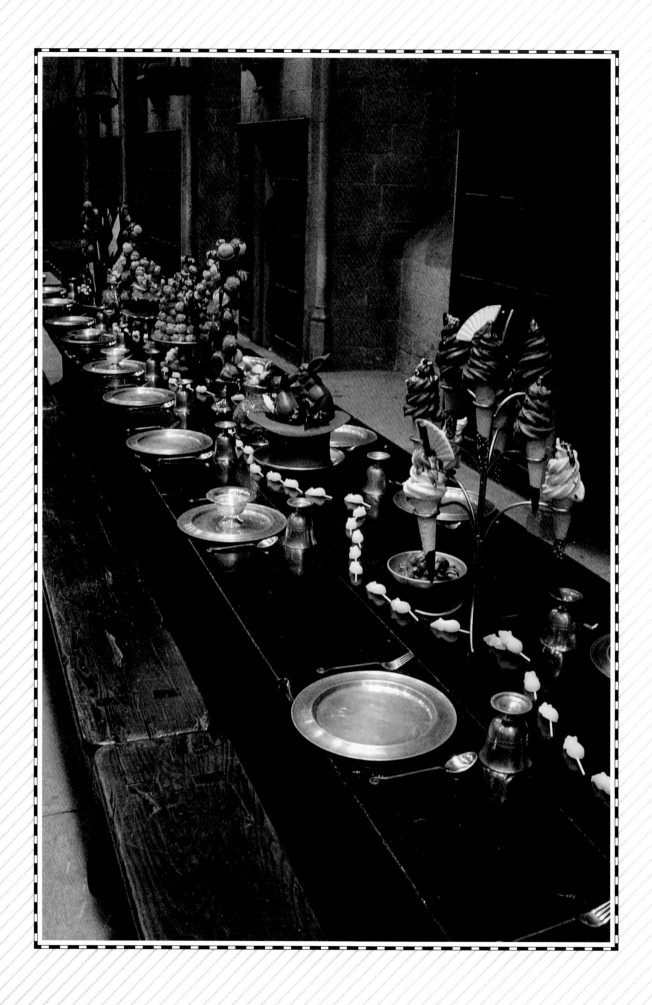

definitely would couldn't be." So, as many of the treats were chocolate, many of the treats had to be made out of resin. McMillan felt that audiences would be hard-pressed to discern which was which: "I think you would find it very difficult to realize that the small chocolates on the dishes aren't edible, because Pierre Bohanna and his team have really perfected the art of food that looks realistic. I think you could easily be fooled by those, though they have real nuts on the top."

Among McMillan's favorite sweets are the "profiterole explosions." These were real profiteroles without the cream inside, drizzled with a faux chocolate sauce. Another was the tiny white (and a few odd pink) chocolate mice that ran along the tables. "We started with one thousand mice, to take into account the fact the children might eat some of them," she admits. Other desserts were also inspired by animals or nature. Chocolate frogs sit atop shiny frosted cakes. A rabbit in a top hat cake was molded from a real folding top hat (the rabbit was not made from a mold). "We started with sixteen of the top hats and really liked them," McMillan says, "so we ended up with sixty-four. We always have to think in huge multiples on Harry Potter. Never do one or two. It's always hundreds." A stacked pumpkin cake was molded from pumpkins that had been used as props in Hagrid's garden. Phoenix-adorned cakes sit at the top table. The original intention was to have cakes made to represent the four Hogwarts houses, but then the designers decided it might be simpler to have several cakes near Dumbledore that represented his phoenix, Fawkes.

One very striking concoction can be found in the towers of ice cream cones. "No-Melt Ice Cream!" McMillan says with a laugh. "We found a shape of cones we liked, made molds, and then let the props department have a ball with them. They're actually very heavy, but they add a bit more color into the room." Pierre Bohanna had already done a version of these for a feast in *Harry Potter and the Prisoner of Azkaban*, and so had perfected the technique—which is, sadly, completely inedible. "It's a combination of resins and powdered glass, a kind used for sandblasting," he explains, "so it's made of tiny little glass beads that give a wonderful iridescence. It sparkles, and it's got just the right texture of ice cream. There're loads of little tricks we develop and use. In order to replicate something, we'll buy a ton of it for research and think, how can we get this quality, this look? Of course, it takes lots of different ideas and lots of tries to get it to work." Once all the feast's foods were decided upon, designed, and created, the props department was tasked with making hundreds of them to serve the hundreds of people in the Great Hall. "We had giant wobbling chocolate trifles, blancmanges, steamed sponge puddings, which are not the prettiest things, and jelly custards, which Mike Newell requested," McMillan affirms. "And a magnificent ribbon cake that if you cut it, would have a most delicious, heavy, chocolaty filling made with rum inside. Well, I dreamed it would, anyway!"

THESE PAGES: More than a thousand white (and a few pink) mice wind around desserts, including jelly custards, profiterole explosions, and chocolate rabbit in a top hat cakes on the Hogwarts tabletops. In order to provide varying heights of the desserts, tall towers of No-Melt Ice Cream—eighty of them—were placed in-between the cakes and puddings, as well as varying levels of soft-serve No-Melt Ice Cream in cones.

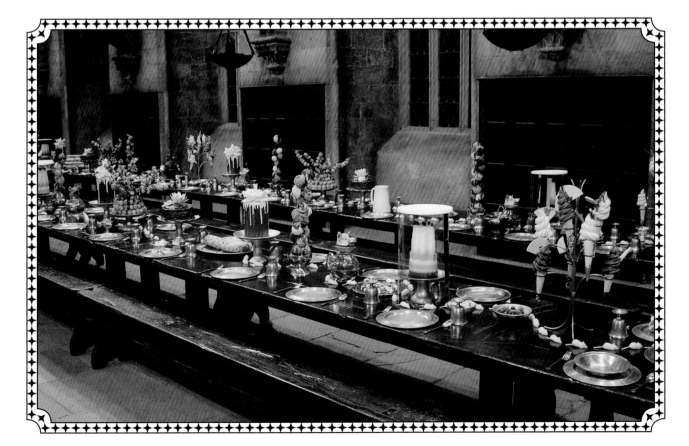

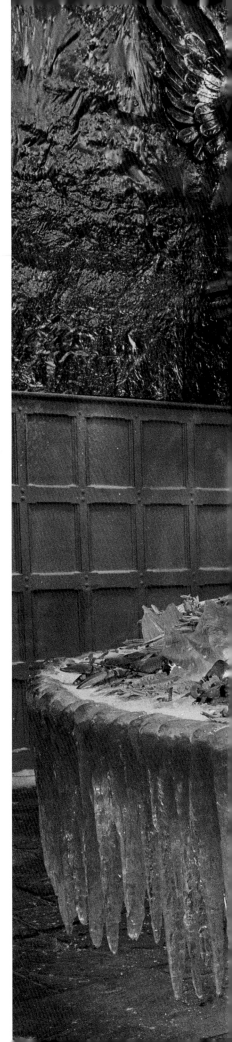

# YULE BALL FEAST

*"The Yule Ball has been a tradition of the Triwizard Tournament since its inception."*

—Minerva McGonagall, *Harry Potter and the Goblet of Fire*

Set decorator Stephenie McMillan had two feasts to serve in *Harry Potter and the Goblet of Fire*; in addition to the Welcome Feast, she needed to provide the food served at the Triwizard Tournament's Yule Ball. Once again, she tried to find something new to serve. "For this one, I thought seafood would be good because, again, we hadn't seen it before. And it would look good on an icy base, which went with the theme of the room." Lessons had been learned from the real food used in the first Harry Potter films and so the majority of the food served was made of resin. To create the faux fish, McMillan and her team ransacked London's famous fish market, Billingsgate, for lobsters, crabs, prawns, and other shellfish. Some were used to create resin molds, but others were real. These were treated so they wouldn't go rancid under the studio lights, meaning no one could eat them, but no one could smell them either.

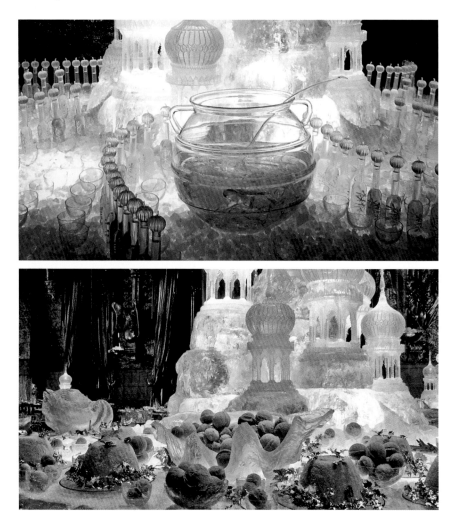

ABOVE: The Yule Ball feast in *Harry Potter and the Goblet of Fire*; BACKGROUND: Positioning and elevation notes for the tables' ice sculpture decorations; OPPOSITE: Resin-molded and a few real shellfish were placed atop tables of resin-molded ice in another new approach to a Hogwarts feast. The clear-cast ice sculpture, created by Pierre Bohanna and the props team, resembles the Royal Pavilion in Brighton, England.

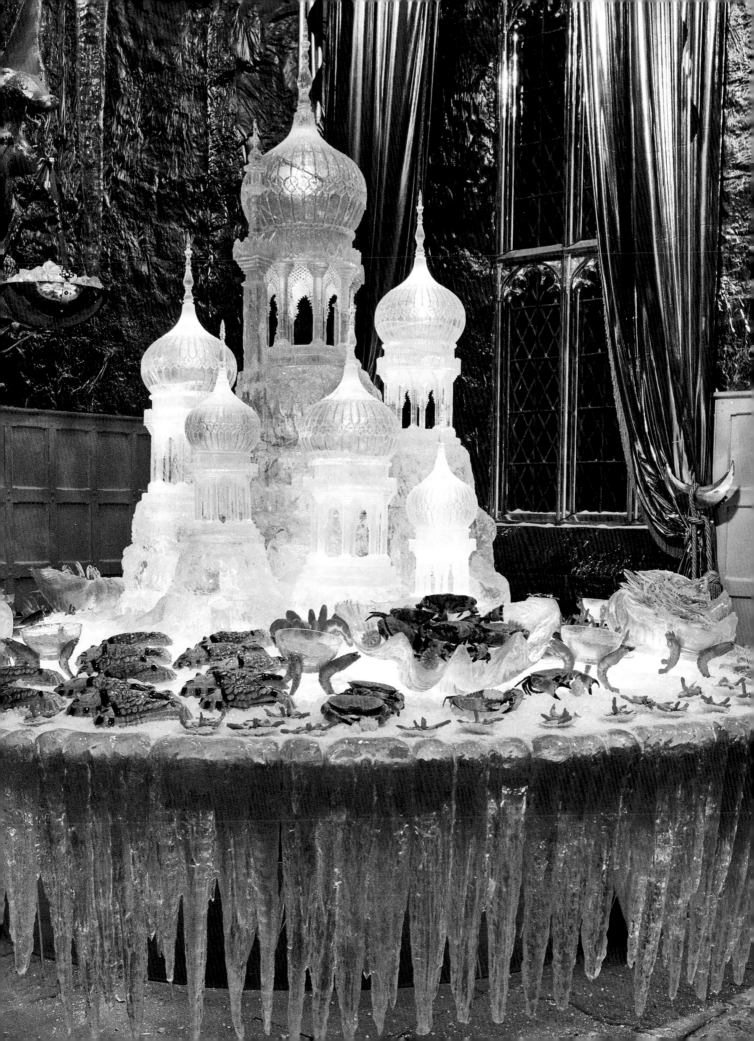

# MAGICAL MUSIC

Two musical groups perform at the Yule Ball. Professor Filius Flitwick (Warwick Davis) conducts a student orchestra at the start of the ball, accompanying the champions' dance with a waltz. The small ensemble plays white or translucent instruments, made of clear-cast resin, which match the icy theme of the Great Hall's decorations. The musicians who comprise the Hogwarts orchestra are members of the Aylesbury Music Centre Brass Band, ages eleven to nineteen. Later on, a wizard rock band takes over the entertainment. "We made all their instruments," Pierre Bohanna reveals. "A twelve-foot-high bagpipe and massive, colossal, clear cymbals. There was a keyboard, guitars, and a full set of drums. They didn't actually work, but they looked as if they did." The band performs onstage in front of a wall of large, chrome megaphones. "We wanted to create a sense of occasion with the band," says production designer Stuart Craig. "But of course, there's no electricity at Hogwarts, so everything is powered by steam!"

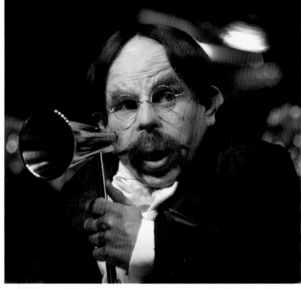

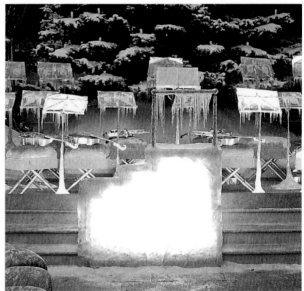

TOP: (left to right) Professor Flitwick; bassist Steve Mackey and front man Jarvis Cocker, both from the band Pulp; Jonny Greenwood, guitarist for Radiohead; and bagpiper Steven Claydon, who played in the band Add N to (X), rock out at the Yule Ball. Director Mike Newell wanted to re-create the dances of his own school years, which would start with formal dancing, "but at the end we'd all let our hair down and have enormous fun"; ABOVE RIGHT: Professor Flitwick introduces the wizard rock band that played at the Ball. Flitwick crowd-surfs during the concert, an idea Davis suggested that he thought no one would actually have him do!; RIGHT: Icy music stands, made of the same clear-cast resin as the instruments, await the student orchestra. Lighting the resin was challenging because, "if you put white light on it," explains prop maker Pierre Bohanna, "it turns pink." Lighting gels gave it an ice-blue tone; OPPOSITE TOP: Jonny Greenwood (right) plays a three-necked guitar, fitting for the *Tri*wizard Tournament. To his left, Steven Claydon tackles some pretty extreme bagpipes; OPPOSITE BOTTOM: The wizard band performed in front of a one hundred megaphone sound system. Scheduled toward the end of the movie shoot, the cast and crew were able to let lose during the scene's filming.

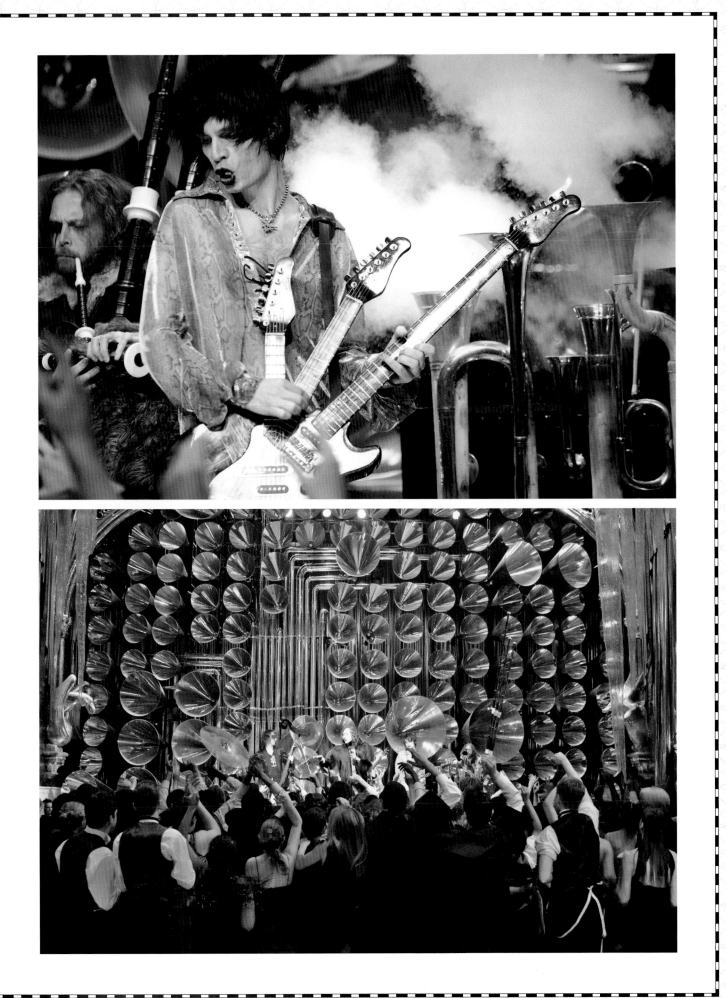

# WEASLEY WEDDING

*"Besides, you've still got the trace on you. We've still got the wedding."*

—Ron Weasley, *Harry Potter and the Deathly Hallows – Part 1*

A bright, happy moment before the tumultuous events of *Harry Potter and the Deathly Hallows – Part 1* is the wedding of the Weasleys' eldest son, Bill, and the Beauxbatons Triwizard champion, Fleur Delacour. Within a huge marquee tent, guests danced, mingled, and feasted on plates of mouth-watering small confectionaries—petit fours, tiny éclairs, strawberries dipped in chocolate—almost all prepared out of silicon rubber. "We did have some real food on the tables for people to be seen eating," says Stephenie McMillan, "but not only did the rubber ones work for decoration, they were also necessary when the tent is destroyed and the guests are trying to escape." McMillan admits that it took several tries to get the right size of the little cakes. "Harry Potter usually has things larger than life, and we were first shown really big flans and huge fruit tarts. So I had to ask for another attempt." The home economist who prepared the edible items for the films came back with meringue swans. "Exquisite—and still too big," says McMillan. "I felt rather guilty saying, 'Well, it's not really quite what I had in mind.'" But it wasn't long before the props department was given the correct-size molds to create the small cakes McMillan had requested. *Four thousand* of them. The reception food was placed on three-tiered confectionary stands molded in breakaway Perspex from a glass version McMillan had found in an antiques shop.

The pièce de résistance of any wedding is the cake—and the Weasleys' was no exception. As the decorative theme of the wedding was French, as a nod to Fleur Delacour's family, "We decided the icing should look like French trellis arches, called *treillage*, found in eighteenth-century French gardens," says McMillan. The design, which encompasses latticework that surrounds four tiers separated by elaborate stands, was worked out on paper and then redrawn into a computer that produced templates to create the treillage. "Which saved us a lot of time with this process, because we didn't have a lot of time to make it," recalls Bohanna. It wasn't that the treillage needed to be produced in a thin inedible material to keep the cast from sampling it, but because the weight of real icing would have been too heavy for the cake's proportions. "The actual cake component of it was a classic cake, albeit proportionately very stretched, because Stuart Craig wanted to make it very tall and slender."

Bohanna remembers that after the cake had been designed, Stephenie McMillan thought it might be a good idea if someone fell into the cake when the Death Eaters arrive and the wedding guests panic and run. "So suddenly we had to think about how to make it into a prop cake where, if someone fell into it, all the sponge and the cream would actually burst out. It seemed impossible because the fineness of the icing underneath each layer of cake is so light, it wouldn't actually be able to hold up under what might be more than twenty pounds for each tier." It might

have *seemed* impossible, but not to the Harry Potter props team. "We did get it to work, making the cake essentially in foam, with very light foam tubes inside, filled with sponge cake and cream. And they actually shot a stunt guy falling through it, but decided against including it because it was too comical in a scene that needed to very dramatic and quite scary." However, Bohanna never thinks any task is wasted. "It's another thing we learned how to do, and so you never know when you'll need to do it again."

TOP: Hermione Granger's beaded handbag; ABOVE: A tiered confectionary stand made of breakaway material holds rubber éclairs, tarts, and meringue swans, all of which are safely destroyed when Death Eaters crash Bill Weasley and Fleur Delacour's wedding and the patrons run in fear; BACKGROUND: A blueprint by Julia Dehoff of the tabletop French-style glass candle holders. The stems were made of rubber and the funnels of breakaway glass; the "candles" were electric gelignite lights that actually lit the actors' faces; OPPOSITE LEFT: Draft work of the treillage cake by Emma Vane shows the proportions and placements of the very delicate icing design; OPPOSITE RIGHT: The finished cake, set with small candied fruits and a large warning not to try to take a taste!

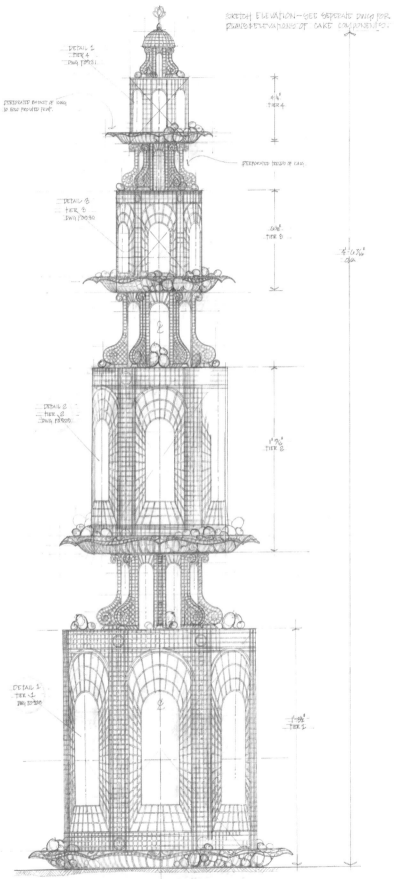

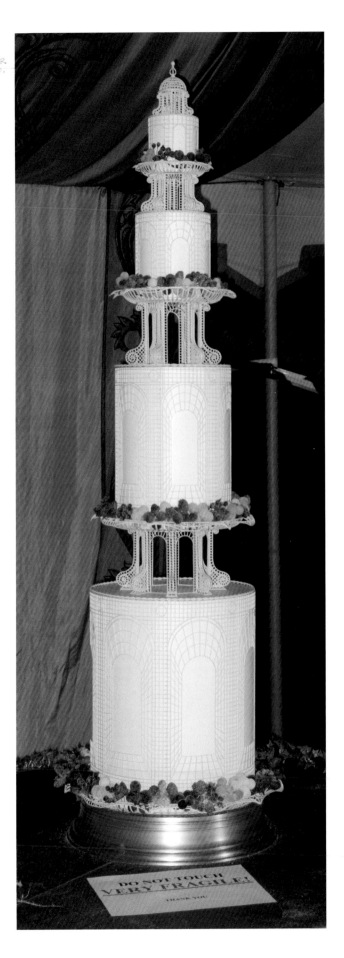

# CHAPTER 2

# PUBLICATIONS

*"Turn to page three hundred and ninety-four."*
—Severus Snape, *Harry Potter and the Prisoner of Azkaban*

# NEWSPAPERS
## AND MAGAZINES

### "He Who Must Not Be Named Returns"
—Headline in *The Daily Prophet, Harry Potter
and the Order of the Phoenix*

It's a well-known visual effect in movies to see a whirling newspaper slow down to reveal a headline proclaiming information that is important to the plot. The newspapers and magazines in the Harry Potter films took this familiar convention and gave it its own unique spin, taking cinematic advantage of the moving images under the headlines of the wizarding world's media to advance the plot or recap necessary information. *The Daily Prophet* and *The Quibbler* were important storytelling devices, used to show the sway of public opinion as the Dark forces rose up and Harry Potter's supporters refused to be put down.

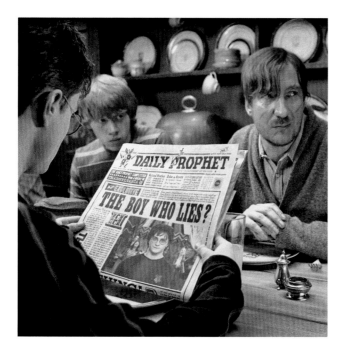

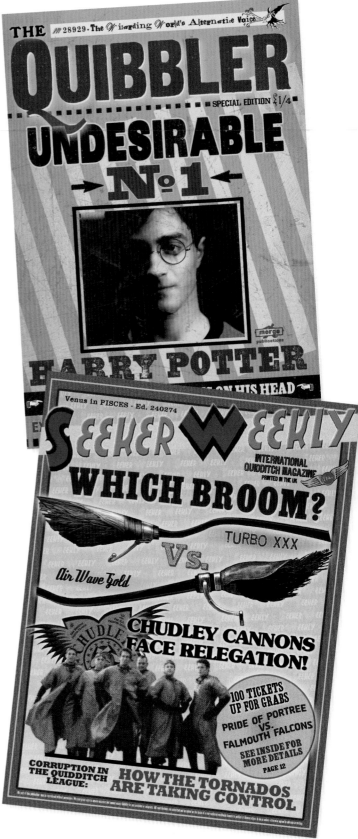

PAGE 26: The printing press used by Xenophilius Lovegood, editor of *The Quibbler,* damaged after the Lovegood house is destroyed by Death Eaters in *Harry Potter and the Deathly Hallows – Part 1;* ABOVE: Ron Weasley and Remus Lupin (David Thewlis) listen in a meeting of the Order of the Phoenix in the kitchen of number twelve, Grimmauld Place, as Harry Potter reads the latest edition of *The Daily Prophet;* RIGHT: Wizard publications include *The Quibbler,* published by Luna Lovegood's (Evanna Lynch) father, Xenophilius (this issue seen in *Harry Potter and the Deathly Hallows – Part 1* and *Harry Potter and the Deathly Hallows – Part 2*), and *Seeker Weekly,* a Quidditch aficionado magazine on Ron Weasley's bedside table in *Harry Potter and the Half-Blood Prince;* OPPOSITE: *The Daily Prophet* reports on the increasingly worrisome anti-Muggle incidents at the opening of *Harry Potter and the Deathly Hallows – Part 1;* FOLLOWING PAGES: Storyboards of *The Daily Prophet* drawn for *Harry Potter and the Order of the Phoenix* illustrate the complicated maneuvers through the paper's text and pictures that will be crafted digitally.

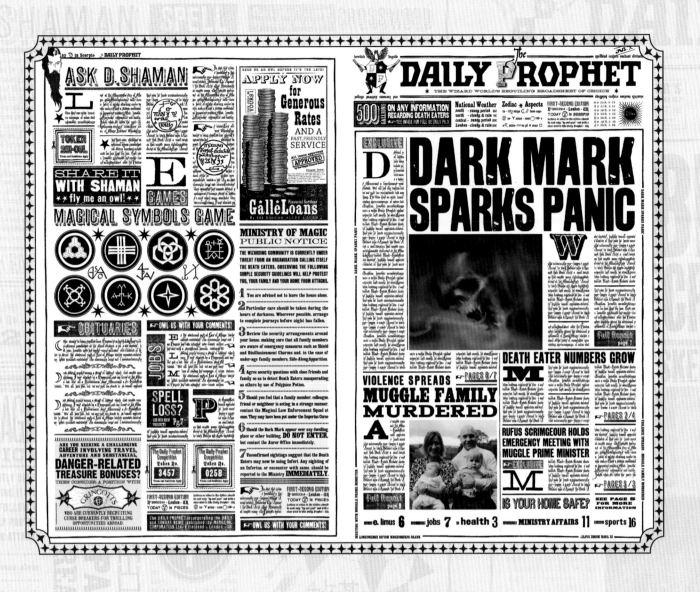

# THE DAILY PROPHET

*"Excuse me, little girl! This is for The Daily Prophet!"*
—*The Daily Prophet* photographer, *Harry Potter and the Chamber of Secrets*

Just as a hero stars in all the films in a series, sometimes so does a hero prop. A vital method of storytelling, and the wizarding world's primary printed news source, *The Daily Prophet* appeared in every Harry Potter film. It was known from the start that the newspaper would feature moving images within it, and so graphic designers Miraphora Mina and Eduardo Lima felt that the text should feel compatible with that. "We didn't know at first if the text might move as well," says Mina, "and that was probably one of the reasons that the pages have the text in spirals and shapes." For the first five films, the *Prophet's* cover page often had text blocks in a design that reflected the story: In *Harry Potter and the Prisoner of Azkaban*, the headline announcing the Weasleys' grand-prize-winning trip to Egypt is in the form of a pyramid; Rita Skeeter's story about Harry Potter and the Triwizard Cup

in *Harry Potter and the Goblet of Fire* is placed, literally, within the outline of the Cup. The newspaper's headline font, created by Mina, reflected the Gothic style production designer Stuart Craig had chosen for the film's architecture; other fonts were taken from old books, Victorian advertisements, and letter presses, but "we had to use an illegible font for the actual story copy," she adds. At first, the designers would place in a sketch for the moving images as a suggestion to the visual effects crew. "We'd send it in for approval," remembers Lima, "but the response would be, 'Well, that's good, but you know it's not the image we'll be using.'" So soon enough, Mina and Lima would simply write "MOVING PICTURE TO BE ADDED LATER" in big letters in the picture box for forthcoming issues. The final printed version of the paper would have green-screen material in the image box, of course.

SHOT CONTINUES.

③.s

OWL US WITH YOUR

TREATY TA

ENDOR

ladrags

WAR

CAMERA SPEEDS
UP.
TURNS THROUGH
180° AND
DIVES RAPIDLY
TOWARD ANOTHER
PICTURE —
HANGING AMONGS
NEWSPAPER TYPE

SHOT CONTINUES.

③.T

J

SCAN

ENDORSE MINISTRY MOVE

PARENTS

CAMERA PUSHES
IN TO PHOTO.

A FIGURE STANDS
BY A FIREPLACE.
BACK TO CAMERA.

0 7 FEB 2006

0 1 FEB 2006

CONTINUES . . . .

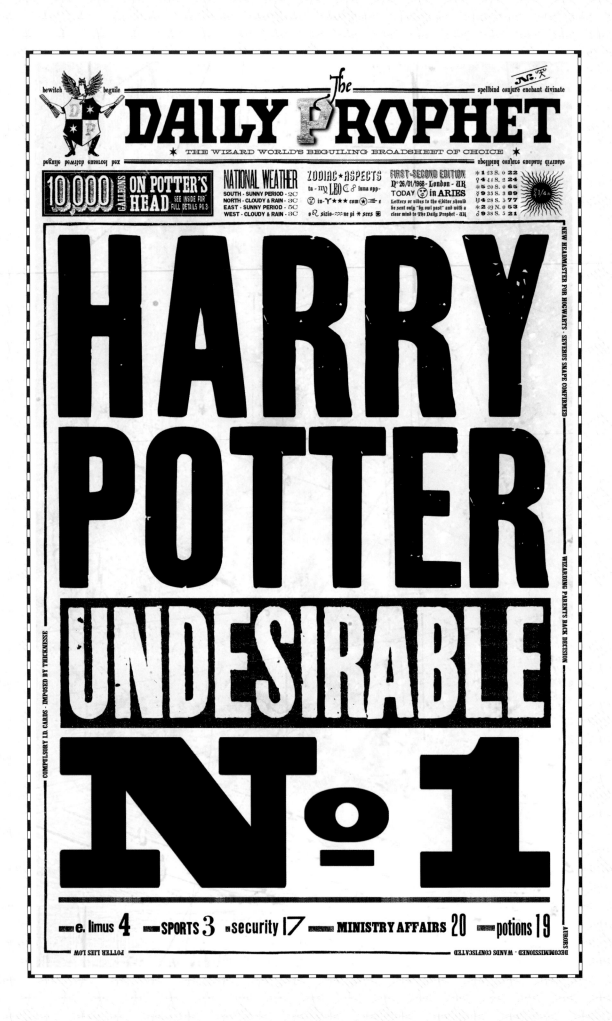

Since *The Daily Prophet* is, well, a daily publication, Mina assumed that the paper would look new, but the filmmakers didn't want white pages, and the paper was given an off-white tint. Their choice of dye was coffee, which added a slight scent to the prop. The pages would be put on the floor to dry, and any wrinkles would be ironed out.

While the headline and specific stories would be dictated by the scripts, Mina and Lima were given a free hand (subject to the filmmakers' approval) with other stories, regular features, and advertisements. Like most newspapers, the *Prophet* offers crossword puzzles (with Escher-like designs that question what is across and what is down), contests (WIN A TRIP TO TRANSYLVANIA), letters to the editor (to be sent by owl post only), horoscopes, classifieds, and advice columns. As for other headlines that were needed to fill out the pages, "We had to come up with these," says Lima, "and we had a lot of fun doing it." "But we're not writers so we pulled ideas from our friends and coworkers," adds Mina. "One of our friends was a ginger, so she featured quite prominently in the issues. She goes to Azkaban for illegal henna (GINGER WITCH SURVIVES HENNA EXPLOSION), then she comes out, but gets arrested again (HOOLIGAN GINGER WITCH ARRESTED IN MUGGLE FOOTBALL MATCH)." Frequently, the names of their fellow graphic artists were used in the ads. "And, of course, we always tried to put our names in it," Lima confirms. M. Mina and E. Lima were the final contestants in a wizarding dueling final, and a mashup of their names became a Dark Arts protection course for the Spellbound Minulimus Method. Lima, among others, also posed for pictures in the ads; one of his is for another course in scuba spells, and he is decked out in full gear. "It's not just us," Lima concedes. "My mum's a writer for the *Prophet.*"

The graphics team estimates that there were forty original editions of *The Daily Prophet* created throughout the film series, although the interiors were often repeated, as they would not be seen on camera. "Sometimes we needed thirty copies, and sometimes we needed two hundred," says Mina. Once an issue was approved, it needed to be recreated quickly. "The work was heavy-duty," she continues, "but with our team, I felt like we had elves."

Once the Ministry begins to take control of the newspaper, starting in *Harry Potter and the Order of the Phoenix*, its style and personality changed. "We discussed it with [director] David Yates," recalls Mina, "and he wanted it to have a dogmatic feel; that nobody had a say anymore, that it was all coming from the Ministry, so this was a big influence on the look." The graphics team was inspired by Russian Constructivism propaganda posters, and so the aesthetic took on a totalitarian tone with bold Soviet-era letters. "The design is always underpinned by the story," Mina explains. The height of the paper was reduced, and Yates also asked for everything to be printed on the horizontal. "We also looked at newspapers from the 1940s," she continues. "When something was really important, they would fill the whole page with one story." As the style of the newspaper changed, so did the design of its title. But Mina and Lima did enhance the "P" of *The Daily Prophet* in gold foil because, as Mina explains, "With such a heavy font, the gold was really just to keep it still, absurdly, magical."

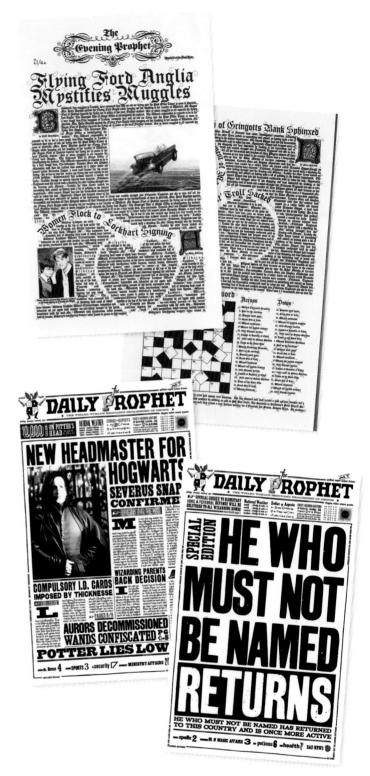

OPPOSITE: A special issue of *The Daily Prophet* was distributed as the Ministry of Magic takes increasing control over the newspaper in *Harry Potter and the Deathly Hallows – Part 1*; ABOVE: The style and personality of *The Daily Prophet* changed drastically from the embellished, free-form style seen in *Harry Potter and the Chamber of Secrets* (top) to the unadorned, block-style distributed in *Harry Potter and the Order of the Phoenix* and *Harry Potter and the Deathly Hallows – Part 1* (bottom); FOLLOWING PAGES: Advertisements in the *The Daily Prophet* feature an acne medication, the Minulimus Method protection course of study, and the Fambus Station Wagon from the Nimbus broom company.

# 500 GALLEONS ON ANY INFORMATION REGARDING DEATH EATERS

### SEE INSIDE FOR FULL DETAILS PG.3

## "For a Flawless Complexion"
## TOLIPAN BLEMISH BLITZER
### 1907
### SPECIAL FORMULA WITH DRAGON CLAW

## DON'T BLAME IT ON THE FOX!

Striped Skunk · Moose · Badger · White-Tailed Deer
Wood Chuck · Raccoon · Porcupine · Coyote
Snowshoe Hare · Muskrat · Dog · Bob Cat

*The Poor Fox*

Since before I can remember the fox has been blamed for almost every thing you can imagine. From fouling tents to killing chickens this unfair victimisation of an innocent animal has to come to an end. Here are a few other animals to look out for before you blame The Poor Fox.

## CRACKED CAULDRON
Brilliant · Bargains
Buy Now · Limited Offer
Only FIVE **5** FIVE Galleons
QUICK FIX · QUICK FIX

## BULMAN'S ULTIMATE WITCH'S HAT LINER
### NEW IMPROVED MODEL!
### REPELS DARK ARTS HEXII

MEASUREMENTS REQUIRED:
1. The Circumference of the Head.
2. Forehead to Poll.
3. Ear to Ear across the Forehead.
4. Ear to Ear over the top.
5. Temple to Temple, round the back.

### WARRANTED TO DELIGHT THE PURCHASER

INDISPUTABLY THE FINEST LINER AVAILABLE TODAY, PATRONISED BY REPUTABLE CONJURERS OF THE WIZANGAMOT OF GREAT BRITAIN, AND THE GENERAL WIZARDING FRATERNITY ALIKE.

### SEND A SELF-ADDRESSED OWL TO BULMAN'S OF WOLVERTON

## NO MORE FOULS IN YOUR O.W.L.s
### SOAR ABOVE EXPECTATIONS
### WITH OUR NEW
CRAM IT!
## O.W.L.S CRAMMER
### Get off to a flying start!

OUR CRAMMERS OFFER YOU A WIDE RANGE OF OPTIONS FROM THE FUNDAMENTALS OF TRANSFIGURATION & HERBOLOGY TO MORE SPECIALISED SUBJECTS, SUCH AS ANCIENT RUNES AND DIVINATION

ENROL NOW AND BENEFIT FROM OUR GREAT 10% DISCOUNT
ACCREDITED BY THE DEPT. OF MAGIC EDUCATION - REG.123-098LK.1

## LONDON CENTRAL & SE

from the manufacturers of FLOOBOOST regular

## Wildsmiths FLOOBOOST PRO
## FLOO POWDER ACCELERATOR
### Enhance Your Floo Networking Performance!

Lizard Storage Issues? Try The New
## Snug Wizards LIZARD BELT!
Safe! · Discreet!

Now holds TWELVE lizards!

YES! please wish me _____ Lizard Belts!
and send them to:
Name:
Address:
Post Code:

NB: Lizard Belt. We hold no responsibility towards the health and safety of any lizard carried in a Lizard Belt, and refuse to consider what affect this may have on breeding and emptying.
Lizards sold separately.

Send us a self-addressed Owl for a free Brochure!

## The Spellbound MINULIMUS METHOD
is proud to introduce an
LIMITED PLACES!
★ Intensive **3** Days ★
## DARK ARTS PROTECTION COURSE

Come & LEARN with TOP WIZARDS!!!

### ADVANCED SPELLS AND CHARMS

### PROTECT YOU AND YOUR FAMILY AGAINST ALL THE DARKEST ARTS!!!

***ENROLL NOW! PLEASE SEND US AN OWL AND A 50 GALLEONS CHEQUE (NON REFUNDABLE)

ENDORSED BY THE MINISTRY OF MAGIC
SATISFACTION GUARANTEED OR YOUR GALLEONS BACK!

## IS YOUR OWL READY?

FOR THE **NATIONAL S.M.S** ➜

SECRET **MESSAGING** ★★★ SERVICE

DOES YOUR OWL STAND OUT FROM THE REST?

GRADE **1** BIRDS URGENTLY REQUIRED

S.M.S IS YOUR OWL WORTHY? RECRUITMENT MEETING AT: WOODSIDE ARBORETUM ON: 17/##

---

★★★ WIZARDING PUBLIC PROTECTION & AWARENESS ★★★

## ALWAYS BE: ON GUARD

DON'T RISK BEING UNPREPARED THE ENEMY CAN STRIKE AT ANY TIME

*PREPARATION* IS THE BEST **PROTECTION**

THE MINISTRY OF MAGIC

---

SAVINGS FREE OF HEXING TAX OF UP TO 3,000 GALLEONS EACH TAX YEAR

START SAVING FROM JUST ONE SICKLE!

## GRINGOTTS

### JUNIOR WIZARD SAVINGS ACCOUNTS

The value of investments may go down as well as up and the skill may not get back the full amount of any additional contributions.

---

IS YOUR FAMILY HEIR BROOM OUT OF DATE?
NOT ENOUGH BROOMS IN THE FAMILY GARAGE?

WE HAVE THE SOLUTION

It's so quiet! It's so smooth!

A REMARKABLE NEW BROOM JOINS THE NIMBUS FAMILY OF FINE BROOMS

REACH NEW HEIGHTS IN THIS NEW NIMBUS STATION WAGON...

NIMBUS STATION WAGON

IT'S THE SMARTEST BROOM WHEREVER YOU GO!

---

## STAMP OUT THE ENEMY

BE AWARE OF DEATH EATERS

REPORT TO THE MINISTRY IF YOU SPOT ANY SUSPICIOUS WIZARDS

---

## MINISTRY OF MAGIC

### WIZARDING PUBLIC AWARENESS NOTICE No. M39h-z

Practitioners of Dark Arts using New "Rune-Sign Language" to Bamboozle Bonafide Witches & Warlocks!

REFER TO MANUAL M39h-z FOR CODE-BREAKING INFORMATION

## BE VIGILANT!

---

★★★★★ SERVICES REQUIRED ★★★★★

### YOUR MINISTRY NEEDS YOU

JOIN THE MINISTRY'S ONLY OFFICIAL ATTACK SQUAD

DON'T FALL VICTIM! SIGN UP NOW

WARNING: MUST BE OF ADULT WIZARDING STATUS SIGN UP

---

# WARNING!

## DEATH EATERS ARE AMONG US!

## HELP US TO HELP YOU!

YOUR INFORMATION IS VITAL

### INFORM IMMEDIATELY

THE MAGICAL LAW ENFORCEMENT SQUAD OF ANY SUSPICIOUS BEHAVIOUR

EAT AS MUCH AS YOU WANT with the new range of potions from Witch Watchers

---

## WAND SERVICING

-NOTHING IS MORE *VITAL* IN THESE DARK TIMES!-

A. WEBB SERVICING LTD.

EPHRAIM LANE, H. HEATH

EST. 1728

ENDORSED BY THE M.O.W

Ministry OF Wands

WAND SERVICING • MOW TESTS • REPAIRS • RECOVERY SERVICE

## YOUR WAND IS YOUR LIFE!

COLLECTION & DELIVERY SERVICE AVAILABLE

---

### DEFENSIVE SPELLS (ADVANCED) TRAINING

INTENSIVE COURSE EXPERT TRAINERS!

MASTER DEFENSIVE WAND SKILLS IN JUST ONE WEEK! ★★★★★

## ENROLL NOW

WARNING: MUST BE 18 + TO APPLY

100% MINISTRY APPROVED No. 1 PROTECTION

---

## PROTECT AGAINST THE DARK ARTS

COUNTER CURSE

Get FREE exclusively

*for a limited time only*

---

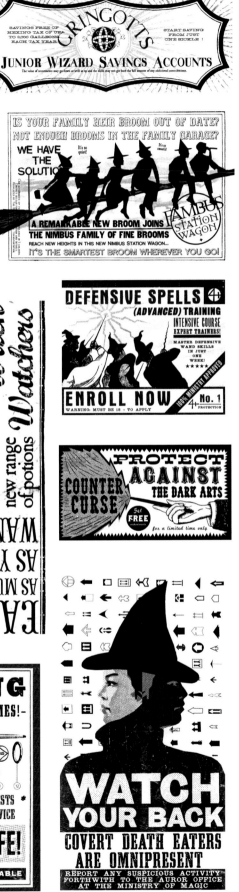

# WATCH YOUR BACK

## COVERT DEATH EATERS ARE OMNIPRESENT

REPORT ANY SUSPICIOUS ACTIVITY FORTHWITH TO THE AUROR OFFICE AT THE MINISTRY OF MAGIC

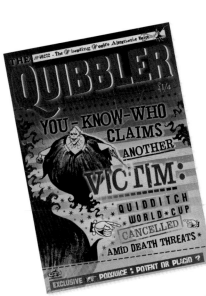

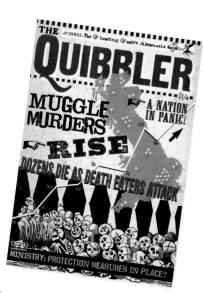

# THE QUIBBLER

*"Quibbler? Quibbler?"*

—Luna Lovegood, *Harry Potter and the Half-Blood Prince*

Edited by Xenophilius Lovegood (Rhys Ifans), *The Quibbler* is "The Wizarding World's Alternative Voice," to quote their masthead. First seen in *Harry Potter and the Order of the Phoenix*, *The Quibbler* was printed on newsprint paper to give it more of a tabloid rag feel, although among its articles about revealing ancient rune secrets or rumors of goblins cooked in pies, it clearly prints truths about what the Ministry's up to and offers unqualified support to Harry Potter. Just as with *The Daily Prophet*, Miraphora Mina and Eduardo Lima were charged with adding text to supplement the headlines required by the scripts. In addition to her appearance in the *Prophet*, the ginger witch is similarly reported on in *The Quibbler* (GINGER WITCH ARRESTED IN CAXAMBU WITH FAKE HENNA). Mina's and Lima's names are used individually (THE LEAD SINGER OF THE HOBGOBLINS AND MINA LIMA ARE THE SAME PERSON!) or in mashups (MY WEEK WITHOUT RUNES BY EUDAPHORA MERGUS). Regular features include interviews and classifieds, a column called "Revelations," and a weekly query about the Muggle world (BARCODES: WHAT'S THE POINT?). The text font used is not so much illegible as unintelligible. Called "Greek text," it's commonly used in the publishing industry to lay out a book's body text in the design before the author turns in the manuscript.

A special edition was created for *Harry Potter and the Half-Blood Prince* to feature Spectrespecs, which Luna Lovegood is wearing when she spots an injured Harry under his Invisibility Cloak (it was the Wracspurts around his head that gave him away). The cover was printed on heavier paper, and the outline of the Spectrespecs was perforated for their removal.

Harry Potter, Ron Weasley, and Hermione Granger get a chance to see where *The Quibbler* is printed when they visit Xenophilius in *Harry Potter and the Deathly Hallows – Part 1*. Five thousand copies of the current issue were printed to pile around his circular house. Additionally, large, vintage wooden typesetting characters were strewn around the room, loaned to Stephenie McMillan from a print museum located in a small town near the Leavesden Studios, and a mechanized printing press was installed. "Maybe only a quarter of his house was living quarters," Stuart Craig explains. "So the special effects team created a press based on an American version from the 1800s, and put the paper on a conveyor belt system. We thought it would be fun to have rollers rushing across the ceiling and up and down the walls." Craig asserts it was "more dynamic, more fun, and more to blow up in the end."

ABOVE AND OPPOSITE: Issues of *The Quibbler*, published by Xenophilius Lovegood, Luna's father. What had originally been more of a tabloid rag, with articles about moon frogs and yeti tracking, *The Quibbler* became an alternative voice against the Ministry of Magic and a staunch supporter of Harry Potter; ABOVE MIDDLE: One of the most popular issues of *The Quibbler* included removable Spectrespecs for spotting Wracspurts, sported by Luna Lovegood; BELOW: A storyboard of Luna Lovegood on the Hogwarts Express distributing that edition of *The Quibbler* in *Harry Potter and the Half-Blood Prince*; FOLLOWING PAGES: Interior pages of *The Quibbler* offered games, spell instructions, and personal stories, including one written by a familiar-sounding Eduaphora Mergus.

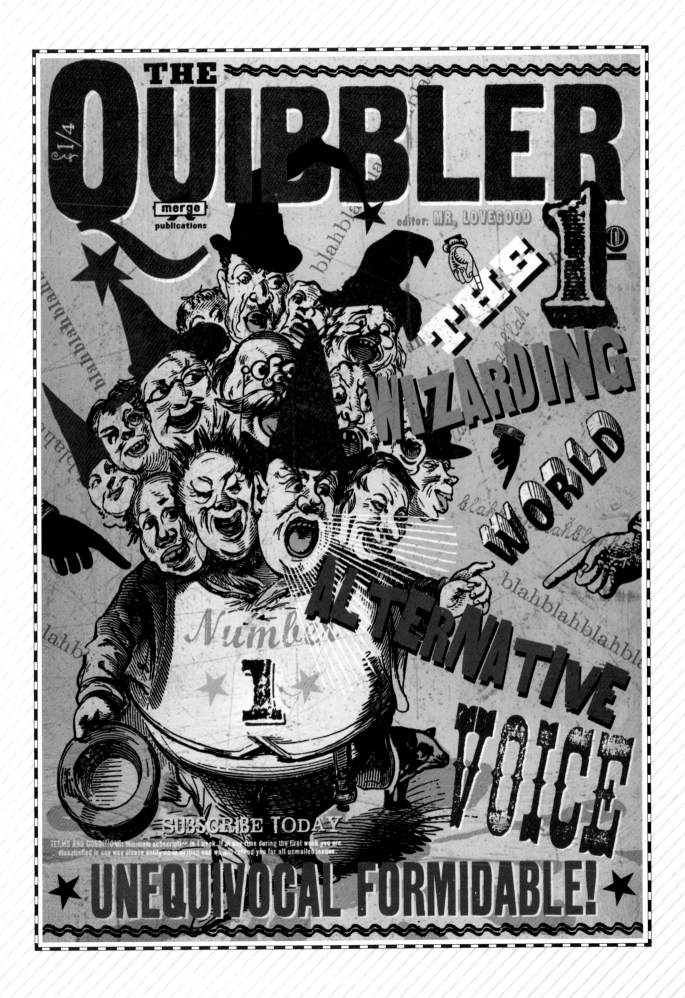

# EXCLUSIVE

## THE LEAD SINGER OF "THE HOBGOBLINS" & MINA LIMA ARE THE SAME PERSON!

asellus accumsan m.Fusce egetl suscipit nonumiy. lor. Nla augue pede, interdum quis, solltudinali quam, feugiat vitae, tortor. Sed erat felis, dictkium ve vida et, feugikiat quis, nisi

metus. Phasellus accumsan massa in lorem.Fusce egetl vel dian nonumiy. ed dol lltudinali interdu e, tortor. quam, f kium ve ed erat quis, nisi vida et, entumqu esent lu Phasellus pulvinar niksi e quam. Aliquam ultricese

ntesque aliqu tincidunt mole auctor klii pulima an sagittis dolor ligula. Su spe Phasellus ulv Proin eu arcu. Nam Curabitur facilisis co metus. Phasellus acc vel diam suscipit nor Sed dolor. Nla augue interdum quis, solltu m, feugiat vitae, to erat felis, dictkiu a et, feugikiat qui esent luctus element Phasellus pulvinar n quam. Aliquam ultri

### EXCLUSIVE

## SPELL STEPS OF THE WEEK:

### WAKEFIELD'S SAMBATA

cilisi. In vel leo fauci luctus. Etiam imentum, nulla sedrl semper, sapien turkp us diam, vel laoreet magna eget massa. Sl disse semper nibh ve vehicula rutrum. Pel que congue tincidunt ris. Proin est quam, diet vel, dignissim n vel. sem. Etiam dio. Proin tvu sa a leuismodm lesu massa nulla c diam, at aliquam mkil us massa in mi. Sed eget re Mhasellus pulvinar nis i quam. Aliquam ultricil sem vel dolor. Cura ur in telly it am ipsumife rr um . Integeir rdi rdum magni ulla In vel augue Nunc vit eo faucibusleo facilisis luctus. Etia imentum, nulla sed semper, sapien tur diam, vel laoreet sa na eget massa. Sus

**OWL US WITH YOUR COMMENTS!**

THE QUIBBLER

# EXCLUSIVE

## WRACKSPURTS

### UNFUSS THE MYSTERY
#### DR. SHAMAN REPORTS

vallis. Rhasellus ulvel yelit Proin eu arcu. Nam atorci. Curabitur facilisis commol metus. Phasellus accumsa massa in lorem.Fusce egetl vel diam suscipit nomu Sed dolor. Nla augue terdum quis, solltud am, feugiat vitae, to ed erat felis, dictkiu vida et, feugikiat qui esent luctus elementum Phasellus pulvinar niksi e quam. Aliquam ultricesse m vel dolor. Curabitur in tellus sit amet ipsum ferm entum posuere. Integer im perdiet interdum illmagna Nulla facilisi. In vel augue Nunc vitae leo faucibusleo facilisis luctus. Etiam imentum, nulla sedrhoncu

Proin eu arcu. Nam atorci. Curabitur facilisis commol etus. Phasellus accumsan ssa in lorem.Fusce egetl diam suscipit nonumiy. dolor. Nla augue pede, dum quis, solltudinali feugiat vitae, tortor. rat felis, dictkium ve et, feugikiat quis, nisi t luctus elementumqu asellus pulvinar niksi e am. Aliquam ultricesse vel dolor. Curabitur in tellus sit amet ipsum ferm entum posuere. Integer im perdiet interdum illmagna Nulla facilisi. In vel augue Nunc vitae leo faucibusleo cilisis luctus. Etiam cond tum, nulla sedrhoncu apien turpkis cur vel laoreet sapien

## 9 GINGER WITCH ARRESTED IN CAXAMBU WITH FAKE HENNA

assa nulla congu diam, at aliquam mkiletus massa in mi. Sed eget re Mhasellus pulvinar nisi et quam. Aliquam ultricili es sem vel dolor. Curabitiour

massa in mi. Sed eget lore Mhasellus pulvinar nisi et quam. Aliquam ultricil ies sem vel dolor. Curabitiour in tellus sit amet ipsumife rmentum posuere. Integeir imperdiet interdum magni Nulla facilisi. In vel augue Nunc vitae leo faucibusleo facilisis luctus. Etiam cond semper, sapien turpis cursi diam, vel laoreet sapienma na eget massa. Suspendisse

### NEXT WEEK

## MUGGLE WORLD BARCODE WHAT'S THE POINT?

4200006200

by a Ministry Insider

pz

## GAMES

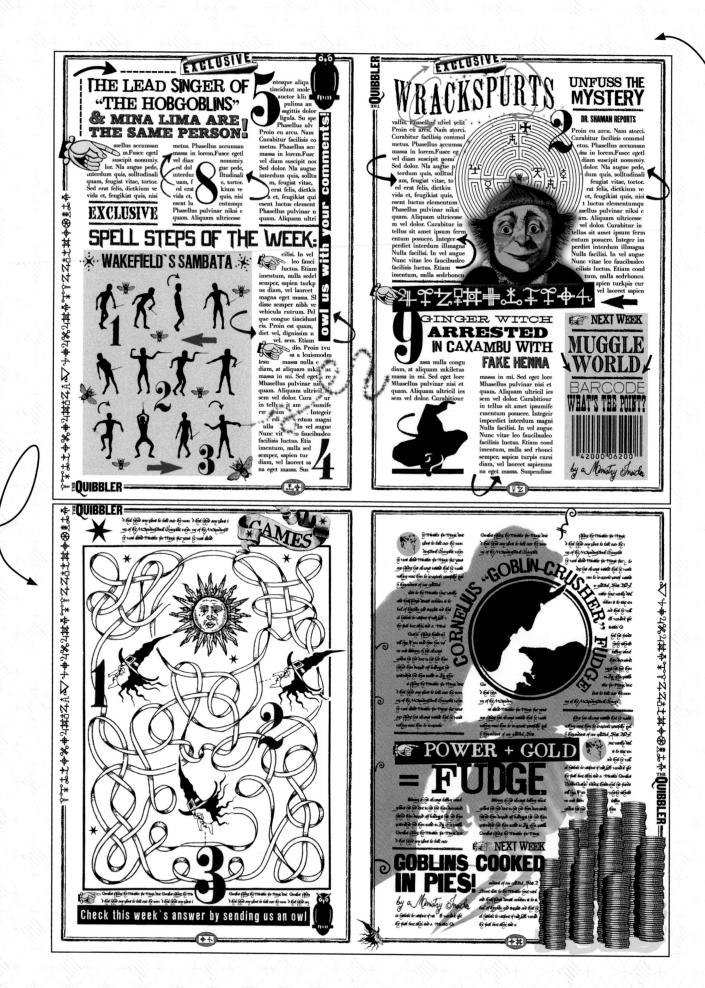

### Check this week's answer by sending us an owl

THE QUIBBLER

## CORNELIUS "GOBLIN-CRUSHER" FUDGE

### POWER + GOLD = FUDGE

### NEXT WEEK
## GOBLINS COOKED IN PIES!

by a Ministry Insider

THE QUIBBLER

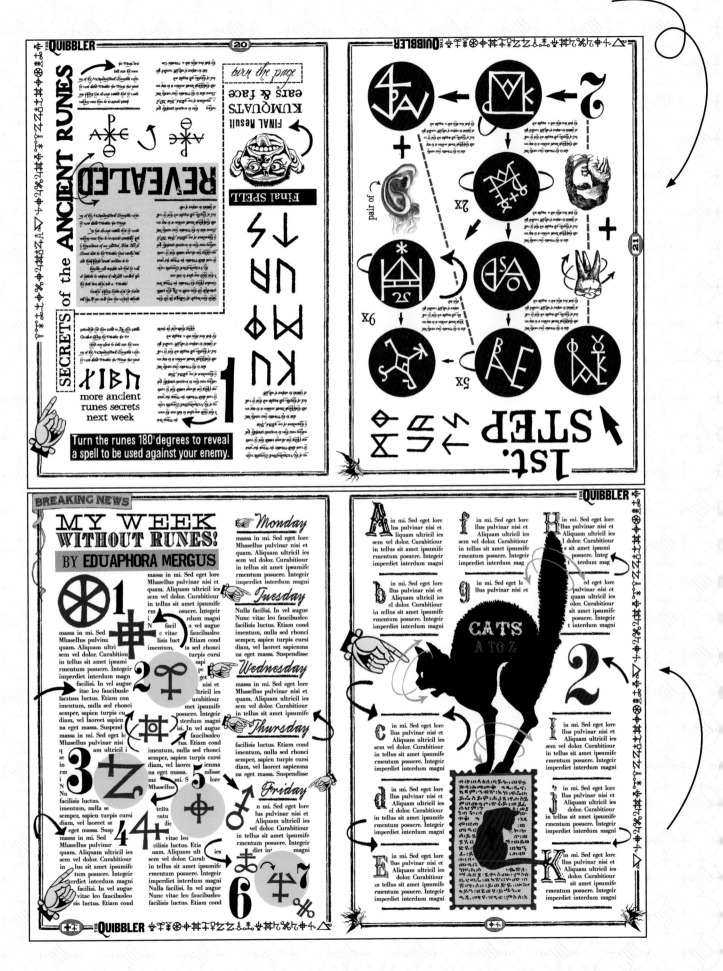

# BOOKS

*"Do you think Neville Longbottom, the witless wonder, could have provided you with Gillyweed if I hadn't have given him the book that led him straight to it?"*
—Barty Crouch Jr., disguised as Alastor "Mad-Eye" Moody, *Harry Potter and the Goblet of Fire*

In addition to the textbooks necessary for Hogwarts classes such as Potions, Defense Against the Dark Arts, and Charms, books were created for Hagrid's hut and Dumbledore's office, for the Hogwarts library (regular and restricted sections), for Neville Longbottom in order to help Harry Potter in *Harry Potter and the Goblet of Fire*, for Hermione Granger to take on their journey in *Harry Potter and the Deathly Hallows – Part 1*, and for author Bathilda Bagshot's house. Books were seen close up, being held by students, and in the distance, so the use or view of the book on camera determined their material and construction. Many of the shelved books in Dumbledore's office were London phone books rebound in faux covers and sprinkled with dust. Some shelves in the Hogwarts library were filled with books in the same way, but there were also books that needed to fly up to their places, for example, in *Harry Potter and the Half-Blood Prince*. Stephenie McMillan's team made these out of a lightweight material. Their "flight" was created by having crew members wearing green-screen gloves reach through the stacks to grasp the books that Emma Watson would hold up. The piles of books in the library and the curved stacks in Flourish and Blotts that seemed to defy gravity were created by the prop makers, who would insert a curved metal bar through a hole drilled in the books, like stringing beads, to create the effect.

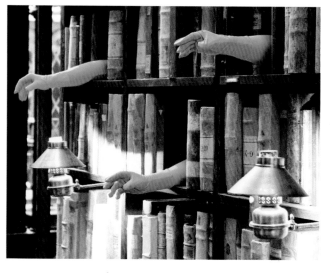

TOP: Harry Potter and Remus Lupin talk over several stacks of bound books after the professor resigns from Hogwarts at the end of the events of *Harry Potter and the Prisoner of Azkaban*; ABOVE LEFT: A tacky book stack, *The Life & Lies of Albus Dumbledore*, from *Harry Potter and the Deathly Hallows – Part 1*; ABOVE: The books that "floated" from Hermione Granger's hand to the shelves of the Hogwarts library in *Harry Potter and the Half-Blood Prince* were caught by crew members; OPPOSITE: The precariously stacked books of Flourish and Blotts bookstore in a reference photo for *Harry Potter and the Chamber of Secrets*.

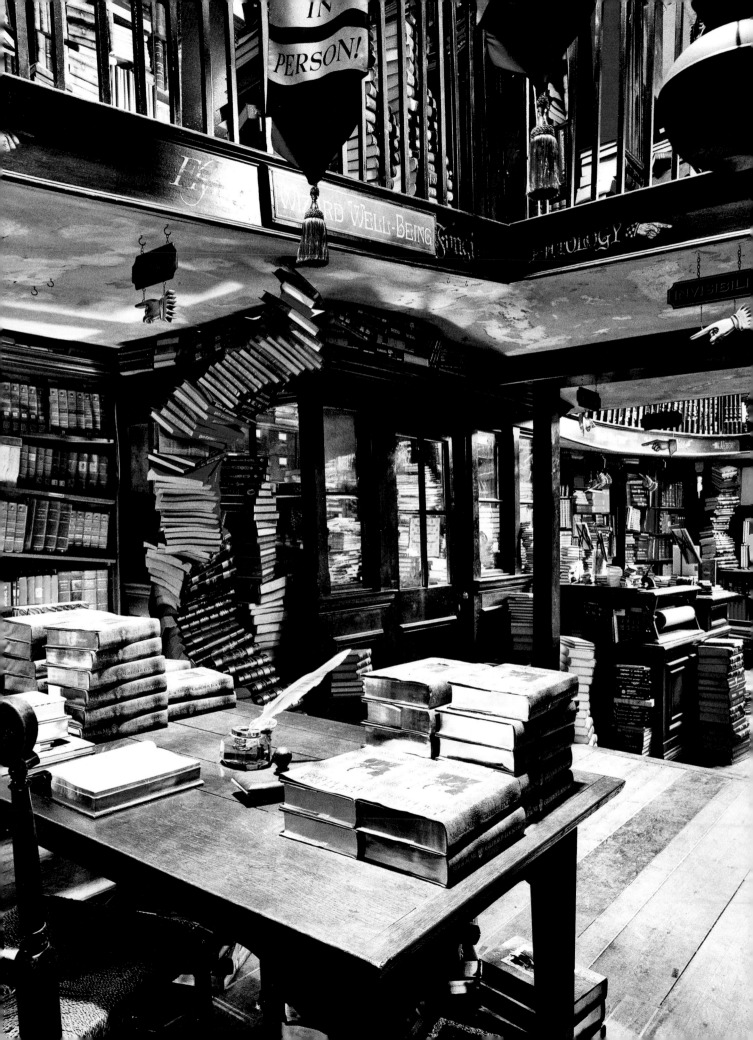

# TEXTBOOKS

*"Honestly, don't you two read?"*
—Hermione Granger, *Harry Potter and the Sorcerer's Stone*

TOP LEFT TO RIGHT: Rubeus Hagrid's copy of *Dragon Breeding for Pleasure and Profit* and the first-years' textbook for Professor McGonagall's Transfiguration class, both from *Harry Potter and the Sorcerer's Stone,* and the textbook for third-year Defense Against the Dark Arts students from *Harry Potter and the Prisoner of Azkaban;* ABOVE: A Defense Against the Dark Arts textbook and a student notebook created for *Harry Potter and the Goblet of Fire;* OPPOSITE TOP: The exquisite cut-out cover of one of the twenty books Hermione takes with her in *Harry Potter and the Deathly Hallows – Part 1;* OPPOSITE BOTTOM: Perhaps the first edition of *Advanced Potion-Making,* crafted with a leather cover debossed with gold symbols.

Before the start of each school term, Hogwarts students would receive a letter listing what books they would need for the subjects assigned to them for the year. Along with writing the text for the pages within, the graphics department created the title treatments and the design and binding of the books. "We worked very closely with bookbinders and learned traditional techniques and processes," says Miraphora Mina. "It was a wonderful experience to engage with other craftsmen, because we wanted to push the boundaries of what you would normally expect in a book binding, and learn how to make covers out of metal and silk and gold leaf."

Miraphora Mina and Eduardo Lima collected a considerable number of old books, which they used as reference both for the binding and its contents, in addition to being able to observe how a book aged; for example, where it broke with daily or yearly use. Once the team, which included their assistant, Lauren Wakefield, decided upon a final design, different-sized editions of the book would be created, again depending upon their time in front of the camera. "There are those books at regular size that the students use," explains Lima, "but when they need to be read close-up on camera, we'll do a bigger version, from twenty-five to fifty percent bigger, especially when you need to read the handwriting, as was the case with the *Advanced Potion-Making* book."

Every book was filled with about twenty pages of text on its subject, written by the members of the graphics department, and these pages would be repeated until they reached the size of the book they wanted. A minimum of copies, usually eight, would be created for each book that was handled by a main character. The

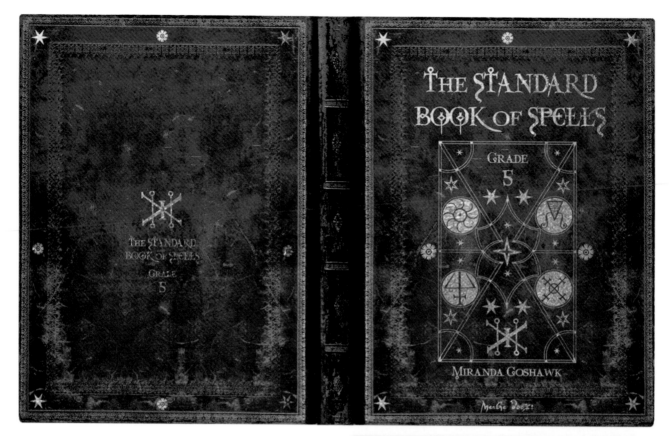

schoolbooks in general would be printed for classes of twenty to thirty students, plus several extras, in case the book was destroyed in a stunt or was accidentally ruined during shooting. Author's names that didn't come from the original novels came from friends, family, or members of the graphics department: *Olde and Forgotten Bewitchments and Charms* is by E. Limus (Eduardo Lima), *Ancient Runes Made Easy* is by Laurenzoo (Lauren Wakefield), and *New Theory of Numerology* is by Lukos Karzos (Miraphora Mina's son). With so many books needed for Flourish and Blotts, new titles were created with a wizardly bent (*A Fully Illustrated History of the Flying Carpet* and *Wanderings of a Tree Through the Alps*), and a few seemed to parallel books from the Muggle world (*Wizards Are from Neptune . . . Witches Are from Saturn*). Familiar names showed up for the publishers: Luca Books, Winickus Press (for graphic artist Ruth Winick), and MinaLima Books.

In *Harry Potter and the Deathly Hallows – Part 1*, Hermione Granger brought many books with her on their journey seeking out the Horcruxes that she thought would be helpful. In addition to any books that had already been mentioned, such as *Moste Potente Potions*, which Hermione used to create Polyjuice Potion, Mina and Lima added others to her cache to total about twenty books, carried in a small beaded bag touched with the Undetectable Extension Charm. This was an occasion when the artists tried to get into the character's skin. "It was a really nice opportunity to think, well, which ones would she have taken on her trip?" asks Mina. "There was a line in the script that described her bag. She shakes it, and there is this terrible noise of stacked books falling over. Sadly, you don't get to see all of them in the film."

TOP: *The Standard Book of Spells* for first years, *Harry Potter and the Sorcerer's Stone*; ABOVE: The *Rune Dictionary* Hermione Granger brings with her in *Harry Potter and the Deathly Hallows – Part 1*; OPPOSITE TOP: *Fantastic Beasts and Where to Find Them*, required reading for first years, *Sorcerer's Stone*; OPPOSITE BOTTOM: Bathilda Bagshot's *A History of Magic*. Versions of this book are seen throughout the film series, but this one features the author's image, played by actress Hazel Douglas in *Deathly Hallows – Part 1*; FOLLOWING PAGES: The array of books seen throughout the Harry Potter series included not only school subjects but topics from sports to psychology to social interaction.

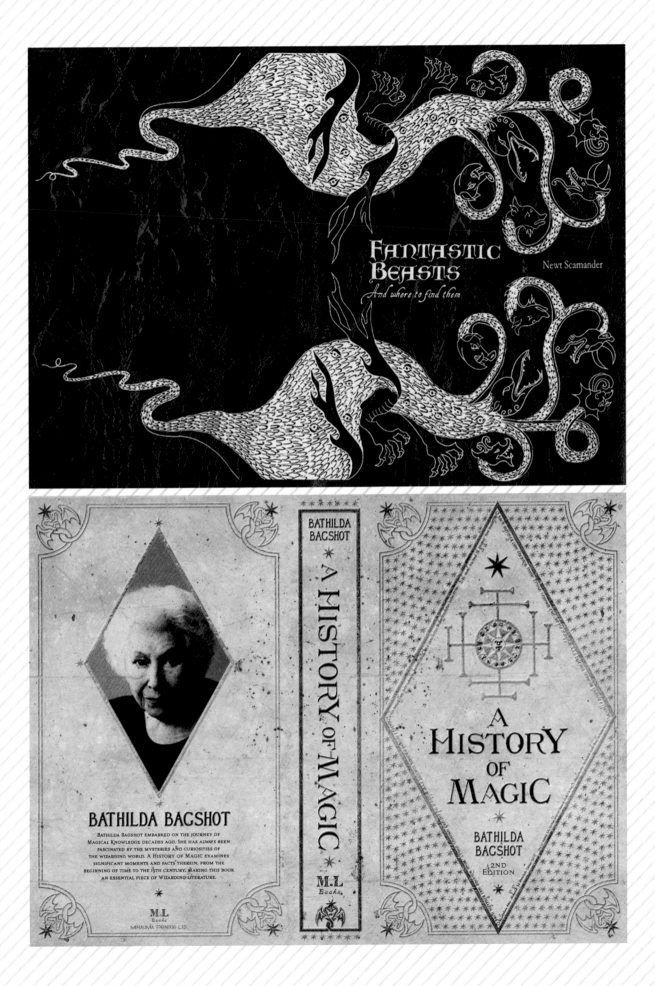

FANTASTIC BEASTS
And where to find them

Newt Scamander

BATHILDA BAGSHOT
A HISTORY OF MAGIC
M.L Books

A HISTORY OF MAGIC
BATHILDA BAGSHOT
2ND EDITION

BATHILDA BAGSHOT

Bathilda Bagshot embarked on the journey of Magical Knowledge decades ago. She has always been fascinated by the mysteries and curiosities of the wizarding world. A History of Magic examines significant moments and facts therein, from the beginning of time to the 19th century, making this book an essential piece of Wizarding Literature.

M.L
Books
MINALIMA PRINTERS LTD.

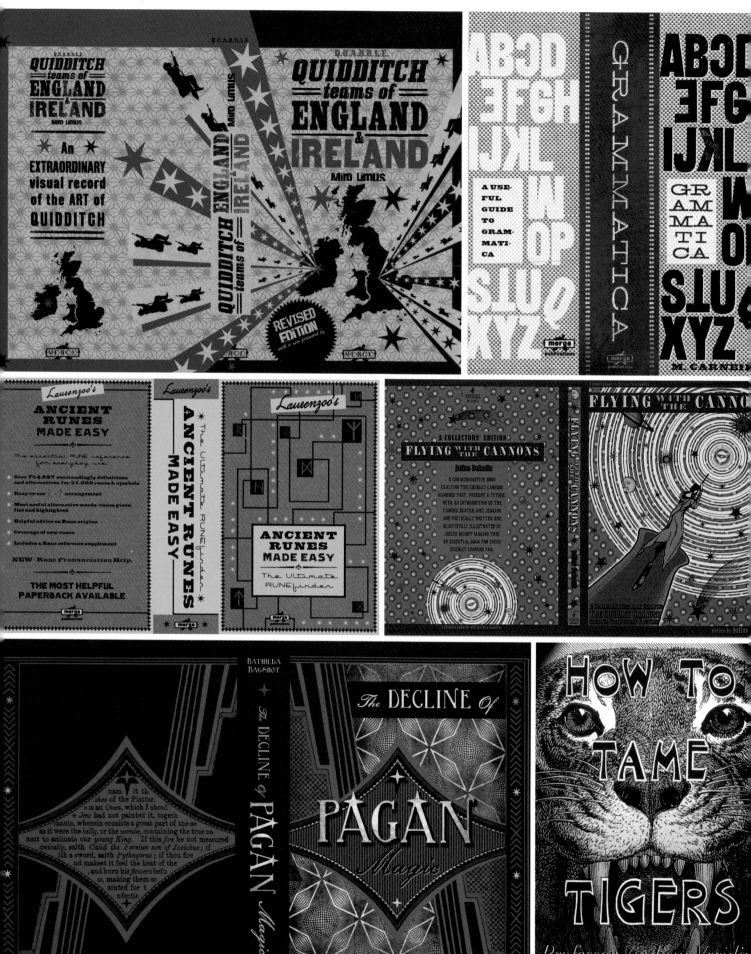

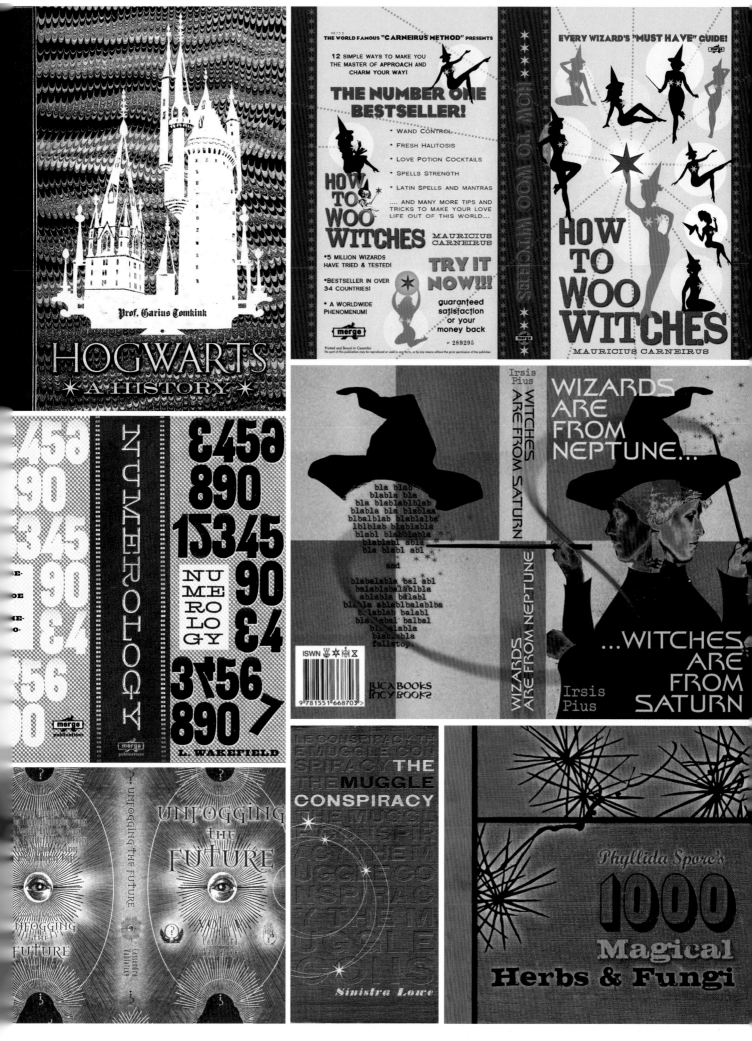

Prof. Garius Tomkink

# HOGWARTS
## ★ A HISTORY ★

---

A0752
THE WORLD FAMOUS "CARNEIRUS METHOD" PRESENTS

12 SIMPLE WAYS TO MAKE YOU THE MASTER OF APPROACH AND CHARM YOUR WAY!

## THE NUMBER ONE BESTSELLER!

* WAND CONTROL
* FRESH HALITOSIS
* LOVE POTION COCKTAILS
* SPELLS STRENGTH
* LATIN SPELLS AND MANTRAS
.... AND MANY MORE TIPS AND TRICKS TO MAKE YOUR LOVE LIFE OUT OF THIS WORLD...

**HOW TO WOO WITCHES**   MAURICIUS CARNEIRUS

* 5 MILLION WIZARDS HAVE TRIED & TESTED!

* BESTSELLER IN OVER 34 COUNTRIES!

* A WORLDWIDE PHENOMENUM!

**TRY IT NOW!!!**

guaranteed satisfaction or your money back

~ 289295

merge

Printed and Bound in Caxambo
No part of this publication may be reproduced or used in any form, or by any means without the prior permission of the publisher.

EVERY WIZARD'S "MUST HAVE" GUIDE!

HOW TO WOO WITCHES

## HOW TO WOO WITCHES
MAURICIUS CARNEIRUS

---

# NUMEROLOGY

Ɛ45ə
890
15345
90
Ɛ4
3Ɛ56
8907

NU ME RO LO GY

merge publications

merge publications

L. WAKEFIELD

---

Irsis Pius

WITCHES ARE FROM SATURN

## WIZARDS ARE FROM NEPTUNE...

bla blab
blabla bla
bla blablablblab
blabla bla blablaa
blbalblab blablalba
lblblab blablabla
blabl blablablla
blablabl abla
bla blabl abl

and

blabalabla bal abl
balablablalablbla
ablabla balabl
blabla ablablbalablba
b lablab balabl
bla babal balbal
bl blabla
blabablabla
fullstop.

ISWN

IUCA BOOKS
IИCY BOOKS

9 781551 668703

## ...WITCHES ARE FROM SATURN

Irsis Pius

WIZARDS ARE FROM NEPTUNE

---

## UNFOGGING the FUTURE

UNFOGGING THE FUTURE

UNFOGGING THE FUTURE

Cassandra Vablatsky

---

## THE MUGGLE CONSPIRACY

Sinistra Lowe

---

*Phyllida Spore's*

# 1000
## Magical
# Herbs & Fungi

# MAGICAL ME AND GILDEROY LOCKHART'S BOOKS

*"When young Harry stepped into Flourish and Blotts this morning to purchase my autobiography, Magical Me—which, incidentally, is currently celebrating its twenty-seventh week atop The Daily Prophet's Bestseller List—he had no idea that he would, in fact, be leaving with my entire collected works...free of charge!"*

—Gilderoy Lockhart, *Harry Potter and the Chamber of Secrets*

The design of Gilderoy Lockhart's published autobiographical adventures, seen in *Harry Potter and the Chamber of Secrets,* was a departure from the brief the graphic artists had received about books for the first film. Word came down to them from J. K. Rowling that the author wanted them to look like the hackneyed books of poor quality you pick up at an airport, at least ones that had been created for mass appeal. Miraphora Mina admits she panicked a bit when she heard this. "I thought, how can we possibly fit something like that into the world we've created that's Victorian and Gothic and very rich in an historical sense?"

When Mina thought more about the possibilities, she realized that Lockhart (Kenneth Branagh) himself was the key to the design. "We knew he was a fake, so we used fake skins on the covers to give the impression that he was trying too hard to be what he was," she explains. "We thought that lent itself perfectly to covers that are trying to imitate the look of snakeskin or lizard skin and that would also connect with his journeys into the wild. So these became suitably tacky and horrible. I felt it was much better that we went down this route rather than just look for shiny, bright colors. These also had a nostalgic feel, but it was still superficial and shallow."

Even the paper chosen for the book came under consideration. "Initially, we chose a thin stock, so you could almost see through it, because that would seem very cheap," explains Lima. "And the producers liked it, but after putting together a sample, we realized it would be a nightmare to print and shoot, so we needed to use a thicker paper." Because each student in his Defense Against the Dark Arts class needed to purchase the entire set of Lockhart's books, multiple copies needed to be created.

The main feature of Lockhart's book covers is a portrait of the man himself. Miraphora Mina and Eduardo Lima came up with a list of suggested environments that could serve as the pictures' backgrounds, and just like filming the moving portraits, a small set was built, costumes fabricated, and the scene shot. "That was really fun," Mina admits, "because it was a step out from the traditional look of everything." Two versions of each book were created. "We had green-

screen material on the book for the bookshop and for when he's signing the books," she explains. "But also had multiple versions of a completely finished book." For the books that wouldn't be seen so closely on camera (for example, for the kids in the back of his DADA class), the static version of the cover was used.

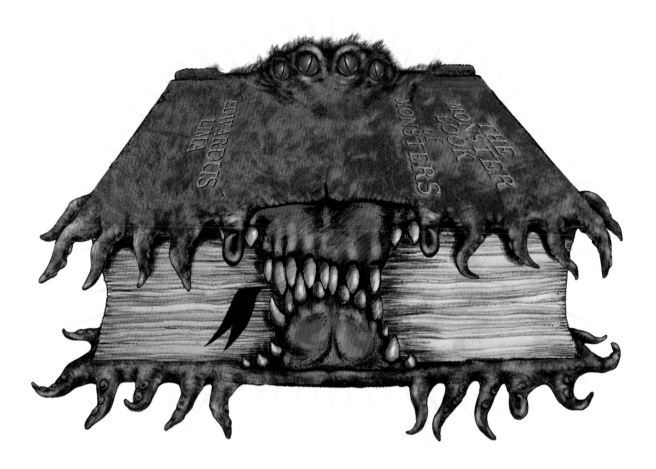

# THE MONSTER BOOK
# OF MONSTERS

*"Gather 'round. Find yerself a spot. That's it.*
*Now, firs' thing yeh'll want ter do is open yer books."*
*"And exactly how do we do that?"*
*"Crikey. Didn' yeh know? All yeh've got ter do is stroke 'em."*

—Rubeus Hagrid and Draco Malfoy, *Harry Potter and the Prisoner of Azkaban*

Many concepts were suggested for *The Monster Book of Monsters*, the book Rubeus Hagrid (Robbie Coltrane) assigns in *Harry Potter and the Prisoner of Azkaban* when he becomes the Care of Magical Creatures professor, including versions with a tail or clawed feet, and even one with a book spine that was made up of, well, spines. Common elements were eyes (in various numbers), sharp, snaggly teeth, and fur. Lots of fur. The monster book's "face" traveled from a portrait to a landscape direction, which would obviously work better by having the opening of the book be where the mouth was placed. Eyes moved from the middle to near the spine to back to the middle (and four of them was the decided number). Miraphora Mina's design offered the ingenious use of the book's ribbon as its tongue. Mina designed the title's typeface and placed the author's name on the cover: Edwardus Limus.

Though the graphics department was usually tasked with creating text to fill a book's pages, in this case, visuals were required, and so some familiar monsters were featured in the entries (goblins, trolls, and Cornish pixies) as well as some unfamiliar monsters created by concept artist Rob Bliss, who offered plant creatures, four-limbed snakes, and something that resembled a cross between a troll and a chicken. Sharp eyes will have noticed that on the Marauder's Map design used for the end credits of *Harry Potter and the Prisoner of Azkaban*, one room is a "Book of Monster's Repair Workshop."

OPPOSITE: The questionably biographical works by Gilderoy Lockhart created for *Harry Potter and the Chamber of Secrets*; ABOVE: Visual development artwork of *The Monster Book of Monsters* by Miraphora Mina with the eyes set on the book's spine, as seen in *Harry Potter and the Prisoner of Azkaban*.

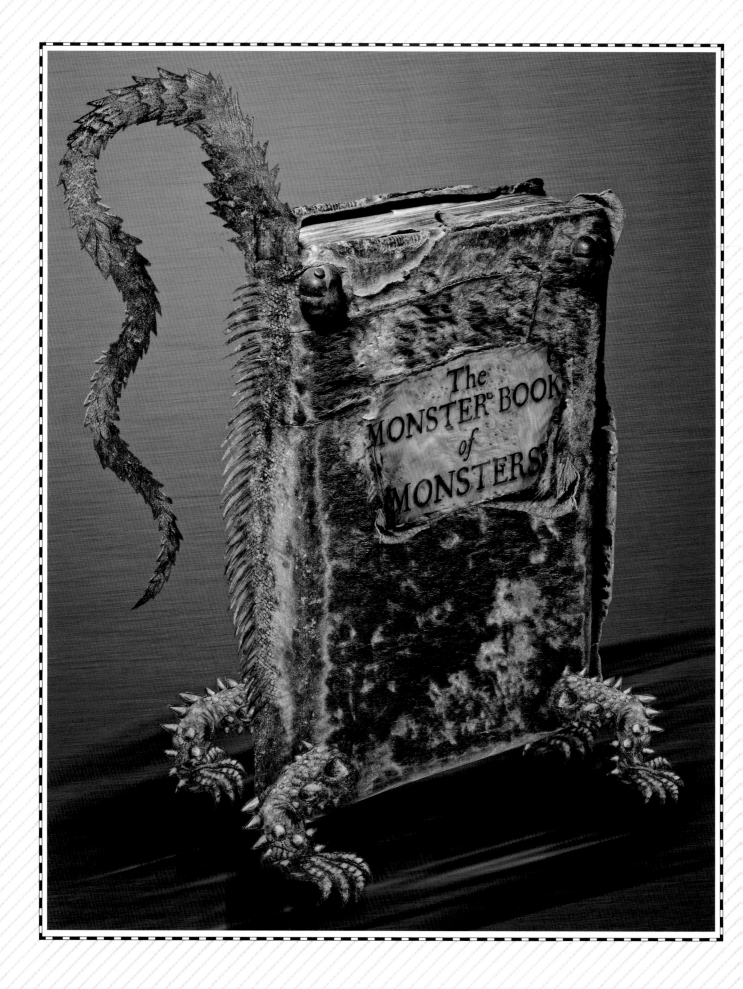

OPPOSITE, LEFT, AND BELOW: Miraphora Mina offered different versions of the *The Monster Book of Monsters*, including one that stood on its own clawed feet and sported a spiny tail; BOTTOM: An interior view of the book features pages on house-elves and mandrake roots, illustrated by the graphic artists in a whimsical style.

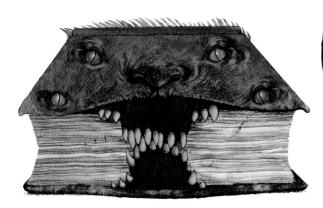

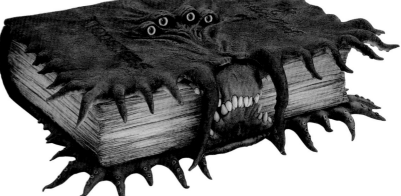

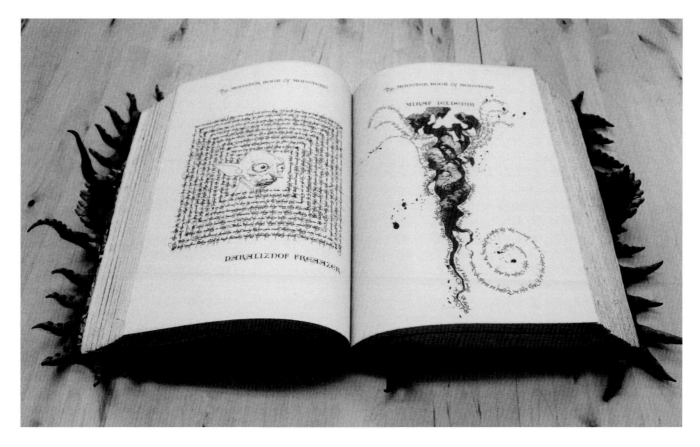

CHAPTER NINETEEN
RUDIMENTARY HOCUS POCUS for
UNSTINKING SINISTER SOCKS

There are some fundamental and distinguishing
factors which will help you to determine
SINISTER from HUNKYDORY.

"But how can I tell?" I hear you say...

1. In the first instance one must examine the
presentation of the said Article and make a
swift assessment ... black or white? Dark or
Light? Pungent or Perfumed?

Tip? COLOUR can reveal the inner Darkness
or Light.
Dear Student....Remember the Golden O.A.P.
rule from Chapter Seven?
Observe, Assess, Prescribe...

68a

DARK ARTS DEFENCE · BASICS FOR BEGINNERS

1. FAVOURED POSITIONS FOR A
LEFT-HANDED HEX-BREAKER

1.    2.    3.

4.    5.    6.

The HEX ZAPPER wards off and destroys
negative energies then attracts positive ones.

68b

# DARK ARTS DEFENSE: BASICS FOR BEGINNERS

*"From now on, you will be following a carefully structured,
Ministry-approved course of defense magic."*

—Dolores Umbridge, *Harry Potter and the Order of the Phoenix*

The new Defense Against the Dark Arts professor in *Harry Potter and the Order of the Phoenix*, Dolores Umbridge (Imelda Staunton), comes with her own idea of how to teach Defense Against the Dark Arts, which is to say they should be taught in theory, and not in a practical application. The book she has selected for the curriculum is decidedly juvenile in appearance. "In terms of choice of design," explains Miraphora Mina, "it was absolutely meant to be putting them down to the primary school level. And that needed to be quickly shown on-screen." Mina was inspired by both the design and construction of textbooks from the 1940s and 1950s. The book is bulky, with a glued-on cloth spine and a printed front and back cover. The illustration on the front goes against the elaborate, intricate designs seen on other textbooks. "They're children playing wizards," she says, "looking at a picture of themselves reading the book with a cover of them looking at a picture of themselves reading the book, in an endless spiral." The graphic team chose a thick paper for the interior pages, because they felt that would give the effect of the book not having much content in it.

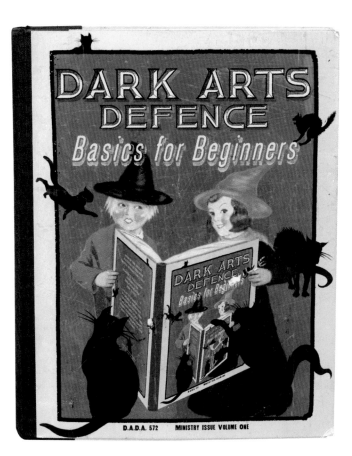

RIGHT: Dolores Umbridge assigned a puerile, uninformative version of the *Dark Arts Defense* textbook when she taught the class in *Harry Potter and the Order of the Phoenix*; TOP: Interior pages of the book were illustrated with dull images and contained mind-numbing content created by the graphics department; OPPOSITE LEFT: The eye-popping cover of Rita Skeeter's (Miranda Richardson) tell-all book about Albus Dumbledore. Information in the book helped Hermione Granger learn about the Dumbledore family in *Harry Potter and the Deathly Hallows – Part 1*; OPPOSITE RIGHT: Albus Dumbledore's letter to Gellert Grindelwald, which is reproduced in *Life & Lies*.

# THE LIFE & LIES OF
# ALBUS DUMBLEDORE

*"I'm told he's been thoroughly unriddled by Rita Skeeter in 800 pages, no less."*
—Muriel Weasley, *Harry Potter and the Deathly Hallows – Part 1*

Similar to Gilderoy Lockhart's books, tabloid reporter Rita Skeeter's tell-all biography of Albus Dumbledore seen in *Harry Potter and the Deathly Hallows – Part 1* also needed to be trashy and cheap. Again, Miraphora Mina and Eduardo Lima were "absolutely stunned," says Mina, "because, in this world, how could we print something so artificial? But we already knew how gaudy and salacious the character was. She's

sensational, so with the design of this book we chose to do that by using really artificial colors, techniques, and finishes." The front cover's graphic burst and spine border is in an acid green color that matches the outfit Skeeter is wearing on the back (her first costume in *Harry Potter and the Goblet of Fire*). Really thin paper was used for the interior; it is one of the few paperback books seen in the film series.

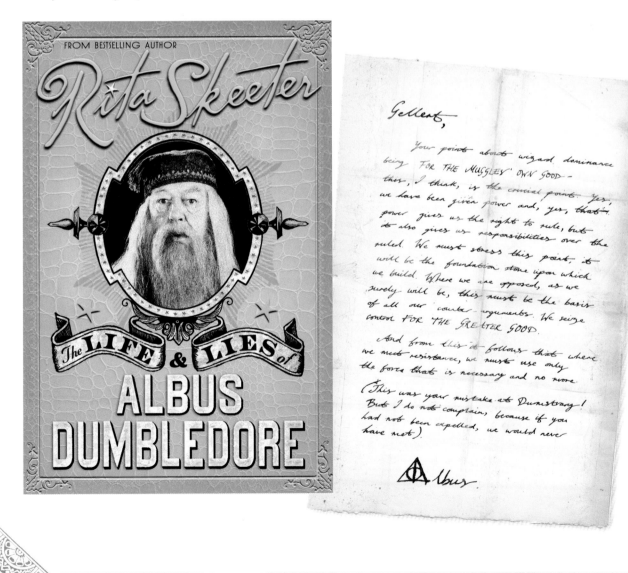

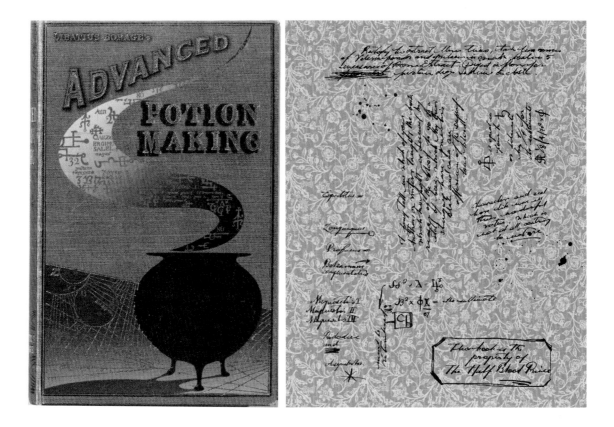

# ADVANCED POTION-MAKING

*"Crush with blade—releases juice better."*

—Written in Harry Potter's textbook by the Half-Blood Prince, *Harry Potter and the Half-Blood Prince*

It is Harry Potter's soaring successes in Potions class that bring him opportunities to bond with (and interrogate) Horace Slughorn (Jim Broadbent), a former Potions master who has been brought back so Dumbledore can confirm if he told Tom Riddle, his student, about Horcruxes. The reason for Harry's success? A copy of *Advanced Potion-Making* marked up by the mysterious and talented Half-Blood Prince. At the year's start, neither Harry nor Ron Weasley expect to be taking Potions, but Professor McGonagall dashes these expectations, and they head to class. Neither has a copy of the required textbook, but Professor Slughorn informs them there are extras in the back cupboard. Of the two, one is new, and one shabby and soiled. Diving into the cupboard, Ron comes up the winner with the newer one, and Harry is left with the used version. But Harry's dilemma is pivotal to the story.

"In this case," explains Miraphora Mina, "we had only a few seconds on-screen to show to the audience why they both want *this* book and neither of them want *that* book, because they don't know *that* book has all the secrets and knowledge that Harry needed for the story to evolve. You've got to remember how it was as a child," she continues. "'I want the shiny one. I'm not going to have that crappy, dirty one.' We had to design a new version and old version that had to be quickly identifiable as the same book, but different

editions." The older edition of *Advanced Potion-Making* is worn, with a Victorian feel in its lettering and a graphic of a smoking cauldron. The more recent edition is smaller, has simple, clean lines, and though it still sports cauldrons, they're more stylized and contemporary (if 1950s can be considered more contemporary).

Harry's edition of *Advanced Potion-Making* has notes scribbled in the margins and around the text by the previous owner, handwritten by Mina. "I was [in charge of] Severus Snape's handwriting, so I had to imagine how Snape would write. Probably he wouldn't have it all tidy and in the same direction, with lots of thinking and scrubbing out." As there were differently sized versions of the book for filming close-ups and middle shots, Mina's notes on the "hero" copy were scanned in and added to the pages digitally before the versions were printed.

OPPOSITE: With help from a notated copy of *Advanced Potion-Making*, Harry Potter (Daniel Radcliffe) brews a perfect Draught of Living Death in *Harry Potter and the Half-Blood Prince*; TOP LEFT: The well-worn second edition of *Advanced Potion-Making* Harry Potter uses to win a vial of Felix Felicis; TOP RIGHT: Notes written in the endpapers of the Half-Blood Prince's copy of *Advanced Potion-Making* were digitally duplicated for multiple sizes of the book seen on-screen.

# MINISTRY PUBLICATIONS

## *"Harry Potter Undesirable No. 1"*
### —Cover page of *The Daily Prophet, Harry Potter and the Deathly Hallows – Part 1*

The Ministry of Magic is the governing arm of the wizarding world in Britain that, overall, establishes and enforces magical law. Headed by Cornelius Fudge during Harry Potter's first five years at Hogwarts, the Ministry went back and forth between repudiating, discrediting, and then reluctantly admitting that Lord Voldemort had returned. The events in *Harry Potter and the Order of the Phoenix* made it apparent that the Dark forces were reassembling, and their rise to power inevitably led to a takeover of the Ministry in *Harry Potter and the Deathly Hallows – Part 1*. As the tenor of the Ministry changed with the involvement of the Death Eaters and other personnel with unquestioning loyalty to Lord Voldemort, the look and feel of the paperwork and publications inescapably associated with any bureaucracy changed to a much more somber and repressive tone.

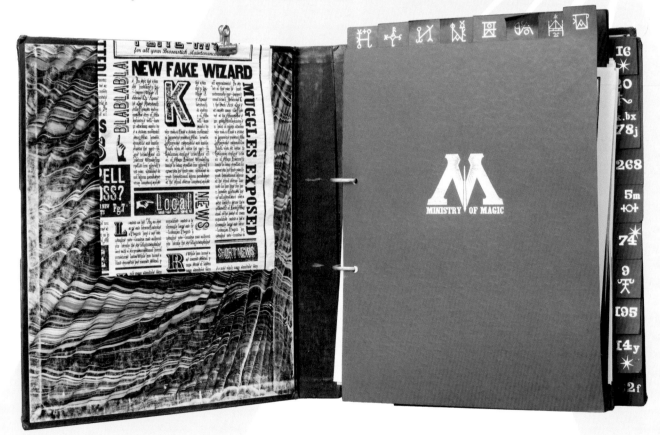

ABOVE: Bureaucratic administrations yield much bureaucratic paperwork. The graphic and prop departments provided notebooks and folders for Ministry of Magic workers to carry it in, *Harry Potter and the Order of the Phoenix*; OPPOSITE, CLOCKWISE FROM TOP LEFT: Ministry of Magic flying memos and a visitor badge created for *Harry Potter and the Order of the Phoenix*; Arthur Weasley's Muggle-Born Registration Commission Registration Form, found by Harry Potter in Dolores Umbridge's office at the Ministry of Magic, *Harry Potter and the Deathly Hallows – Part 1*; Letter to Arthur Weasley from Mafalda Hopkirk, stating the charges and time of the disciplinary hearing for Harry's violation of the Decree for Reasonable Restriction of Underage Sorcery, *Harry Potter and the Order of the Phoenix*; Official Ministry of Magic stamps; Letter to Harry Potter regarding his breaking the Decree for Reasonable Restriction of Underage Sorcery, *Harry Potter and the Order of the Phoenix*.

**Dear Mr Potter,**

The Ministry has received intelligence that at twenty three minutes past six this evening you performed the Patronus Charm in the presence of a Muggle.

As a clear violation of the Decree for the Reasonable Restriction of Underage Sorcery, you are hereby expelled from Hogwarts School of Witchcraft & Wizardry

Hoping that you are well,

*Mafalda Hopkirk*

London in Scorpio

# MINISTRY PARAPHERNALIA

*"Hoping you are well, Mafalda Hopkirk."*
—Letter to Harry Potter, *Harry Potter and the Order of the Phoenix*

Harry's first visit to the Ministry of Magic in the films was in *Harry Potter and the Order of the Phoenix*, when he is brought in for a disciplinary hearing for performing underage magic (vanquishing two Dementors with a Patronus). Ministry paperwork created by the graphics department included visitor badges, official stamps, flying memos, and various correspondences.

★ MINISTRY OF MAGIC ★
**VISITOR**
No. 10201
This pass is issued subject to the Ministry of Magic Health and Safety Regulations 1945-83 & 946-HD and should be returned to reception before leaving the premises
This badge must be displayed at all times

Ref. No. 3966-IO8-HJP

Dear Mr. Weasley,

Due to the current circumstances we are informing you as guardian for Harry James Potter, that the Disciplinary Hearing for the offences stated below will now take place on 12th of August at 8am in the Courtroom IO at the Ministry of Magic.

The charges against the accused are

• The accused in full awareness of the illegality of his actions produce a Patronus Charm in the presence of a Muggle,

• The accused used magic outside the school while under the age of seventeen.

Hoping that you are well,

*Mafalda Hopkirk*
Commander-in-Chief
Improper Use of Magic Office

Ministerial Code of
Confidential Communications
Conduct 572 B

In Accordance with
Ministry for Magical
Missives Guidelines 992X

Ref. No. 3966-IO8-HJP

DEPARTMENT OF LAW ENFORCEMENT IMPORTANT GUIDELINES - 1233K-45 - Decree No. 1567klio-000094 9833-ip6l N. of MAGIC

Mr. A. Weasley
The Burrow
Ottery St. Catchpole

Ref. No. 3966-IO8-HJP

---

✦ 5679

# MUGGLE-BORN REGISTRATION COMMISSION
ADMINISTRATIVE REGISTRATION DEPT. ISSUED BY: M.O.M
ORDER: NO.902-MBRC/✦
CONFIDENTIAL

**NAME** : WEASLEY, Arthur     **IDENTITY NO.** : ✦✦68-WEA/⊕

**DATE OF BIRTH** : ✦4/⊖/✦5

**BIRTHPLACE** {Town : ////  Country : England

**PROFILE** {Eye Colour : Green  Hair Colour : Fair/Red  Weight : 154 lbs  Height : 5 FT. II IN  Complexion : Fair

**MARKS/SCARS** : Red hair is distinctive family trait.

**SCHOOLING** : Attended Hogwarts School of Witchcraft and Wizardry.
HOUSE: GRYFFINDOR

**WIZARDING FIELD** : MINISTRY EMPLOYEE

**BLOOD STATUS** : PURE-BLOOD.
( With unacceptable Pro-Muggle leanings ).
- Known member of the ORDER OF THE PHOENIX.

**FAMILY** : Wife (PURE-BLOOD), seven children, two youngest at Hogwarts.
NB. Youngest son last seen in the company of UNDESIRABLE No. 1.

**MARITAL STATUS** : Married
**SPOUSE (IF APPLICABLE)** : WEASLEY, Molly

**OFFSPRING** { No. of Boys : 6   NONE   No. of Girls : 1   NONE

**ADD. INFO** : ////

**SECURITY STATUS** : TRACKED.
ALL MOVEMENTS ARE BEING MONITORED.
Strong likelihood UNDESIRABLE No.1 will contact.

**WHEREABOUTS** : ////

TRACKED

INFORMATION AQUIRED ON : 08/✦/✦   M.O.M. Central Dept.

**SECURITY LEVEL** : VERY HIGH RISK [XXXX]

MINISTRY
AUTHORISATION
CODE

APPROVED BY: *F.L. Mansfield*

**RANK** : CHIEF REG. AUTHORITY

*Dolores Jane Umbridge*

FORM APPROVED : 090585   - 2709 - MOM AUTHORITIES LW-AM

---

Ⓜ MINISTRY OF MAGIC

TO IDENTIFY : WEASLEY, AR...
IDENTITY NO. : ✦✦68-WEA/⊕

# EDUCATIONAL DECREES

*"Educational Decree No. 23: Dolores Jane Umbridge has been appointed to the post of Hogwarts High Inquisitor."*

—**Proclamation sign,** *Harry Potter and the Order of the Phoenix*

Educational Decrees were laws created by the Ministry of Magic, seemingly to improve discipline and assign punishments for student transgressions at Hogwarts, and enacted by Dolores Umbridge during her tenure as Defense Against the Dark Arts professor in *Harry Potter and the Order of the Phoenix*. These proclamations were the Ministry's attempt to wrest control of the school from Dumbledore. They are, as the bottom of the Decree declares, "subject to approval by the Very Important Members of Section M.I. Trx." And in a clever imitation of government-speak, the last line on the Educational Decrees, hidden by the frames, reads: "Blah blah blah bl Ahbla Blah . . . Bla Blah blabish."

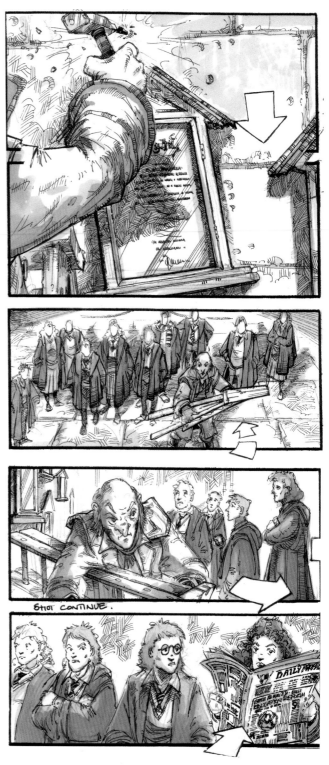

TOP LEFT: Dolores Umbridge, in her capacity as the Ministry appointed High Inquisitor, created more than a hundred Educational Decrees intended to undermine and control the Hogwarts students in *Harry Potter and the Order of the Phoenix*; LEFT: Draft work by Gary Jopling of the Educational Decrees placed around the doors to the Great Hall; ABOVE: Storyboards illustrate caretaker Argus Filch (David Bradley) hammering yet another proclamation into the stone wall; OPPOSITE TOP: Cover of the Ministry Identity Card booklet; OPPOSITE MIDDLE AND BOTTOM: Identity cards for Mafalda Hopkirk (Sophie Thompson) and Reg Cattermole (Steffan Rhodri).

# MINISTRY OF MAGIC IDENTITY CARDS

Identity cards were created for *Harry Potter and the Deathly Hallows – Part 1*, which Harry, Ron, and Hermione use to infiltrate the Ministry when they use Polyjuice Potion to become three Ministry workers. The IDs were produced in moving and non-moving image forms, with green-screen paper in place of the static photograph.

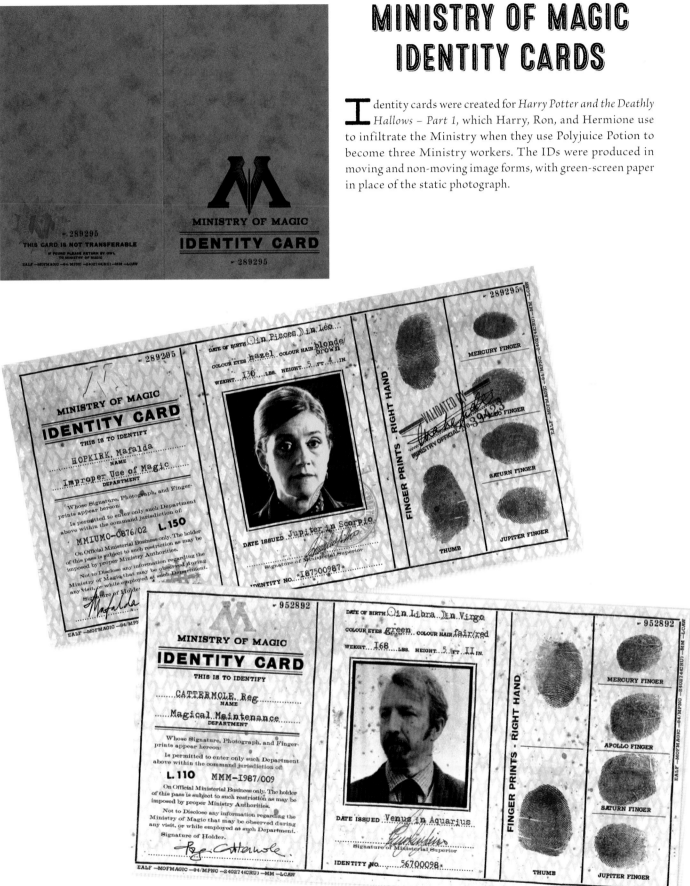

# MUGGLE-BORN REGISTRATION COMMISSION

*"I'm half-blood! My father, my father was a wizard!"*
—Scared man, *Harry Potter and the Deathly Hallows – Part 1*

Dolores Umbridge had many jobs in her work for the Ministry, but perhaps none so heinous as being Head of the Muggle-Born Registration Commission, which registered and persecuted non-pureblood wizards during the events of *Harry Potter and the Deathly Hallows – Part 1* and *Part 2*. It is to Harry's disgust, as he riffles through Umbridge's desk, that he sees registration forms for the members of the Order of the Phoenix, the photos of deceased members having been crossed out with a large red X.

BELOW: The graphics department created form after form for the inquisitions held by the Muggle-Born Registration Commission—these, for Mary Cattermole, were reviewed by Dolores Umbridge, *Harry Potter and the Deathly Hallows – Part 1*; RIGHT: Harry Potter discovers the forms for his friends and loved ones in Dolores Umbridge's desk; OPPOSITE: The graphics used on Mudblood propaganda items in *Harry Potter and the Deathly Hallows – Part 1* echoed the blocky, spare style of the Cold War Soviet Union era.

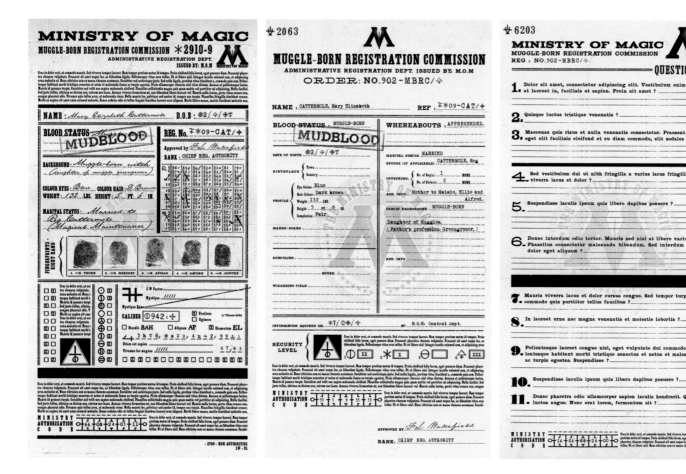

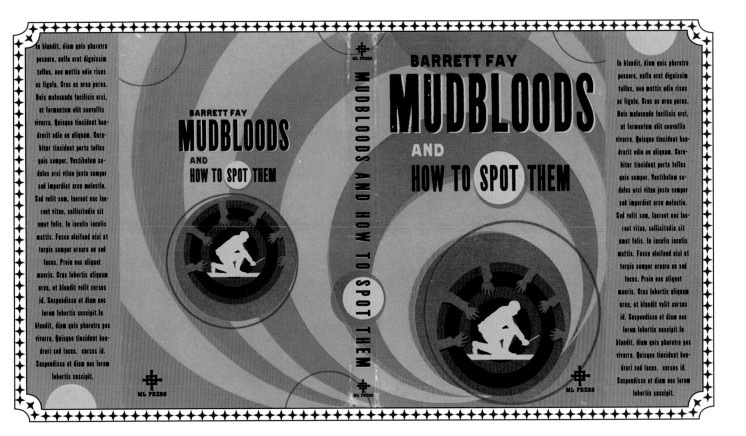

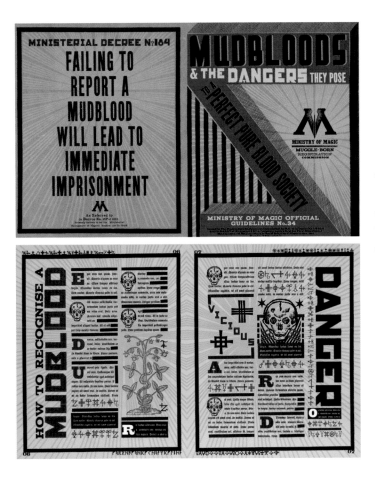

# MUDBLOOD PROPAGANDA

*"Let's get back to work please. Calm down."*
—Wizard in the Muggle-Born Registration Commission office,
*Harry Potter and the Deathly Hallows – Part 1*

Umbridge's office also distributed anti-Muggle literature such as *Mudbloods and How to Spot Them* in *Harry Potter and the Deathly Hallows – Part 1*. Director David Yates suggested that Miraphora Mina and Eduardo Lima look at Soviet propaganda of the post–World War I era, which used primary colors and bold lettering on posters and in pamphlets to be eye-catching and to incite heightened emotions. This style was a total antithesis to the Gothic and Victorian familiarity of Hogwarts and the wizarding community.

# WANTED POSTERS

*"Remember: Negligence costs lives."*

—Printed on Lucius Malfoy's CAUGHT poster, *Harry Potter and the Deathly Hallows – Part 1*

The graphics department had to satisfy both sides of the battle between good and Dark forces throughout the Harry Potter films. Wanted posters were first created for Sirius Black (Gary Oldman) in *Harry Potter and the Prisoner of Azkaban*, where the symbols on his booking slate loosely translate to "more or less human." Eduardo Lima admits that even though some of their work was for a somber subject, "One of the most enjoyable aspects of working on the films was being given the freedom to add your own little touches. On Sirius's wanted poster, for example, we asked for information to be delivered by owl."

A decidedly darker tone was applied in *Harry Potter and the Deathly Hallows – Part 1*, where Public Safety Notices warning of threats from Death Eaters changed to posters for the capture of Undesirable No. 1—Harry Potter—distributed by the Ministry. Eduardo Lima and Miraphora Mina "damaged" the posters to show evidence of them being exposed to rough weather conditions or simple hooliganism where they hung in Diagon Alley.

RIGHT AND BELOW MIDDLE: The wanted poster for Sirius Black, posted throughout the wizarding world in *Harry Potter and the Prisoner of Azkaban*, was created in two versions: a "flat" version containing a still photo and text, and another with a green screen in place of the photo so that moving footage of actor Gary Oldman could be composited in during postproduction; BELOW LEFT AND RIGHT AND OPPOSITE: These posters were pasted on walls in Diagon Alley and Hogsmeade in *Harry Potter and the Deathly Hallows – Part 1* and *Part 2*.

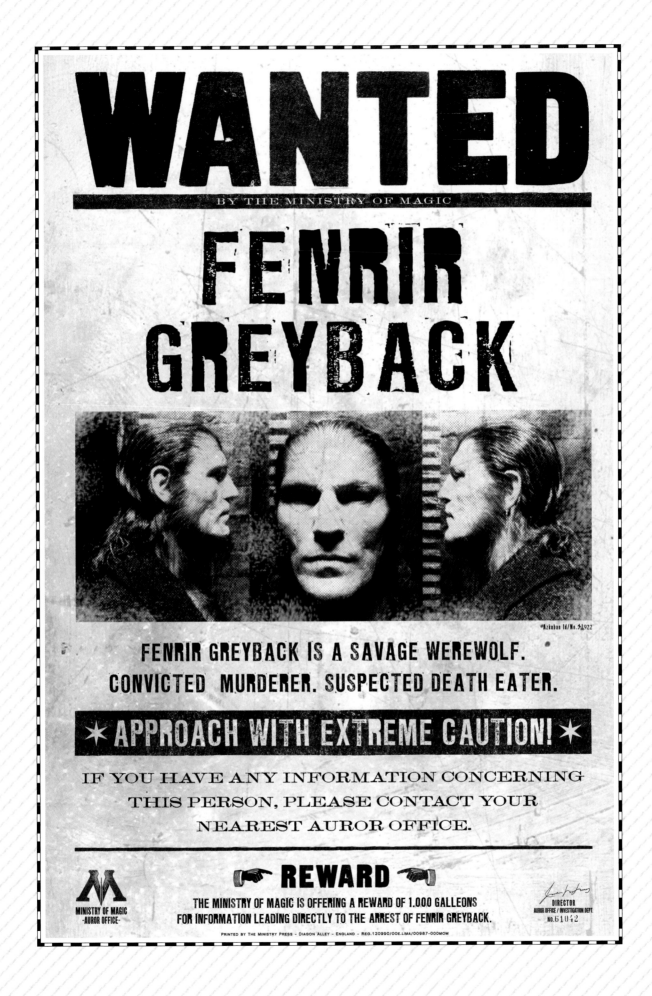

Copyright © 2020 Warner Bros. Entertainment Inc. HARRY POTTER characters, names and related indicia are © & ™ Warner Bros. Entertainment Inc. WB SHIELD: ™ & © WBEI. WIZARDING WORLD trademark and logo © & ™ Warner Bros. Entertainment Inc. Publishing Rights © JKR. (s20)

PO Box 3088
San Rafael, CA 94912
www.insighteditions.com

 Find us on Facebook: www.facebook.com/InsightEditions
 Follow us on Twitter: @insighteditions

All rights reserved. Published by Insight Editions, San Rafael, California, in 2020. No part of this book may be reproduced in any form without written permission from the publisher.

Library of Congress Cataloging-in-Publication Data available.

ISBN: 978-1-68383-836-4

Publisher: Raoul Goff
President: Kate Jerome
Associate Publisher: Vanessa Lopez
Creative Director: Chrissy Kwasnik
Design Support: Lola Villanueva
Editor: Greg Solano
Managing Editor: Lauren LePera
Senior Production Editor: Rachel Anderson
Production Director/Subsidiary Rights: Lina s Palma
Senior Production Manager: Greg Steffen

Written by Jody Revenson

Insight Editions, in association with Roots of Peace, will plant two trees for each tree used in the manufacturing of this book. Roots of Peace is an internationally renowned humanitarian organization dedicated to eradicating land mines worldwide and converting war-torn lands into productive farms and wildlife habitats. Roots of Peace will plant two million fruit and nut trees in Afghanistan and provide farmers there with the skills and support necessary for sustainable land use.

Manufactured in China by Insight Editions

10 9 8 7 6 5 4 3 2 1